Professional
Industrial
Photography

Professional
Industrial
Photography

Derald E. Martin

AMPHOTO
American Photographic Book Publishing:
An Imprint of Watson-Guptill Publications
New York, New York

Copyright © **1980** by Derald E. Martin

Published in New York, New York, by
American Photographic Book Publishing:
an imprint of Watson-Guptill Publications,
a division of Billboard Publications, Inc.

**Library of Congress Cataloging in Publication
Data:**

Martin, Derald E.
 Professional industrial photography.
 Includes index.
 1. Photography, Industrial. I. Title.

TR706.M37 778 80-17474

ISBN 0-8174-4008-9

Manufactured in the United States of America

10 9 8 7 6 5 4 3 2 1

Dedication

Dedicated, in affection and respect, to the talented and creative men and women of Northrop Ventura's Arts and Graphics Department, with whom it was my privilege to work so long, and whose loyal efforts made the boss look good.

Contents

Acknowledgments

Anyone who undertakes the writing of an overview of a field as broad as industrial photography is going to find he needs some help. I did, and I got it—a lot of it—from more people than I can possibly list here. But I do owe a special debt of gratitude to: old school buddies Hank Fagliano of Bethlehem Steel, Al (Opal G) Saiget of Teledyne Ryan, and Hank Harada of Northrop; Jack B. Grossman, of Lawson Products; Bill Jack Rodgers of Los Alamos Scientific Laboratory; contributors Steve Kahn, George Meinzinger, and Tom Engler; my former troops in Arts and Graphics, and Park Irvine of Public Relations, Ventura Division, Northrop Corporation; and last, my long-time friend and, more recently, editor, Lou Jacobs, Jr., who first conned me into taking on this project, then cut my deathless prose to ribbons with his little blue pencil, trying to make it intelligible.

Thanks, folks.

Foreword

I have been in the field of industrial photography for more years than I want to talk about, and I like to think that I kept myself pretty well informed as I went along; I attended seminars and trade shows, saw exhibits of all kinds of photography and art, joined organizations for the exchange of ideas, and read literally hundreds of books and magazines. Yet in the process of writing this book I had to do some research and ask a lot of questions about particular facets of our work with which I thought someone else might be more familiar, and I learned much that I had not known about before. Most of this new material found its way into the book, and for that reason I hope that even the experienced industrial photographer will find in it something of value.

But this is not intended as a reference book for the old pro. It is meant to be of help to the student who is considering the field as a career, to the man or woman who has made up his or her mind to go into industrial photography and wants to know where to begin, and to the photographer in the entry-level job who wants to know more about the field and what to do next.

This is a general overview of industrial photography with specific details only where those details are unique to *industrial* photography. In several places we discuss the technical and practical solutions to lighting problems most likely to be faced by the industrial photographer, but we do not get into the artistic and esthetic ramifications of lighting itself; to do so properly would require ten times as much space as we could spare for it in this book. The same is true of the chapter on the laboratory. We talk about the problems of industrial photo lab equipment and layout, because those are specific *industrial* photography problems; we do not talk about printing controls, two-solution developers, and selective bleaching techniques, because to go into that kind of detail about lab procedures, methods, and materials would require an entire book by itself.

Photographers tend to be thinking, creative, interested—and opinionated—people. I talked with two similarly talented and successful freelance annual-report photographers about the amount and importance of color versus black-and-white photography in annual reports. I got answers that were intelligent, knowledgeable, positive—and diametrically opposed.

Photography is like that. In this book I have made a lot of statements, comments, and recommendations that are based on all that I have learned in a lifetime spent in photography, and if you really tried you would find someone who would disagree with almost any of them. This isn't a bible, it's a book on industrial photography.

I hope you will find it useful.

This striking picture of equipment used for research on meson particles was made by Bill
Jack Rodgers, Chief Photographer, Public Information, at Los Alamos Scientific Laboratory.

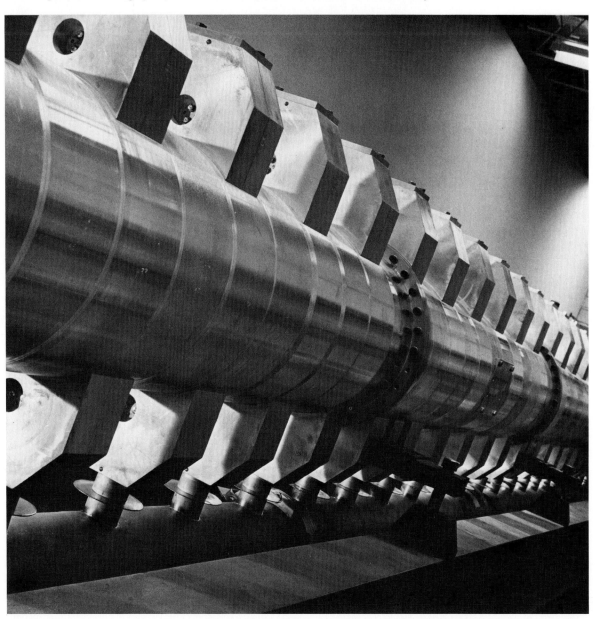

I

This Is Industrial Photography

The field of industrial photography is so broad and so varied that just defining it accurately can be difficult. The photographers who photograph the work of the welders and bulldozer operators on the Alaska pipeline are industrial photographers. So also are the photographers who cover the testing of space vehicles at the White Sands Missile Range and the launchings of oil tankers in Seattle. And so, for that matter, are those who make passport photographs for their companies' traveling executives, and executive portraits for inclusion in the corporate annual report.

THE GENERAL OUTLOOK

Generally, industrial photography is any photography done in support of industry, and in this context we broaden the definition of industry to include essentially all business operations, and even those functions of government that use photography in their work.

Obviously, it is a wide field. Besides making the expected pictures of machinery and operations, the industrial photographer produces illustrations for magazine covers, advertising photographs, public relations pictures, executive portraits, passport and I.D. pictures, medical, safety, and security pic-

tures, pictures of test operations, and catalog pictures of the company's products. The industrial photographer may be sent to photograph operations overseas, or to photograph the progress of a new plant being built in another state.

In the laboratory, the industrial photographer processes color prints, makes murals and color slides, makes printed and etched circuit negatives, makes X-ray photographs, or ''blows up'' single frames from movie film to make prints for technical reports. The capper to all this is that in many companies, all or most of these jobs may be performed by just one individual, or by a very small team—each member of which is expected to be reasonably proficient in each of several different specialties.

WHO IS THE INDUSTRIAL PHOTOGRAPHER?

The photographers who provide all this photographic support fall into two entirely different categories, although the work they do overlaps considerably. There are those who work directly within the industries they serve, as employees of their particular companies, and those who operate on the outside as in-

dependent contractors, or freelances. If you are considering entering the field, you will want to give serious consideration to the important advantages and disadvantages of each side of the fence that divides the "captive" photographer from the freelance. One of the purposes of this book will be to help you define and evaluate those differences so that you can better decide which of the two areas would be the more satisfying for you.

Industrial photography is a field so broad, so full of opportunity and challenge, that there is room in it for people of any disposition, with any degree of talent, and with any level of training. If you like working with people, there are thousands of jobs that provide almost constant contact with others; if you like to work alone or with a maximum of one or two others, there are jobs to accommodate you. It is possible to get an "entry-

Industrial photographers see a lot of the country, sometimes from 40,000 feet. Midair refueling over New Mexico was photographed by Bill Jack Rodgers of L.A.S.L.

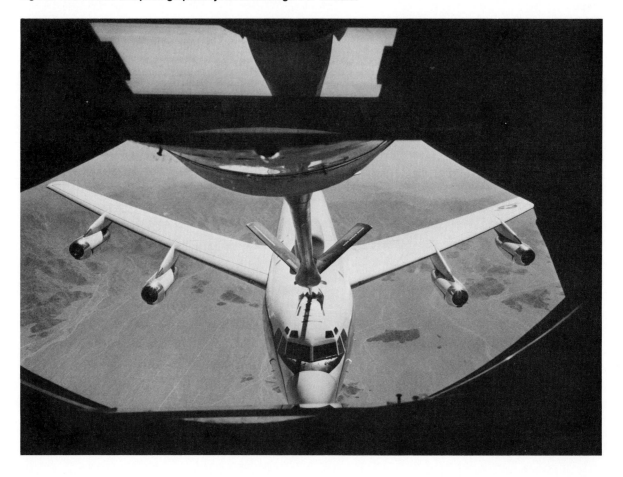

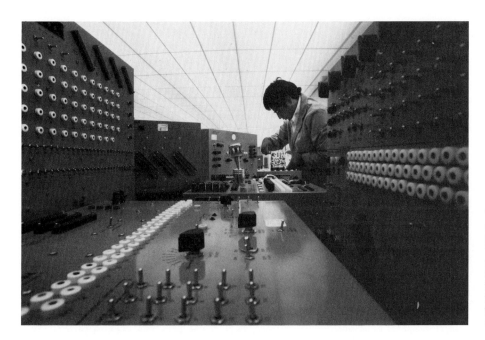

The photographer as designer: Someone else made the parts, but Robert Thornton, staff photographer with the Northrop Corporation, arranged them into a photograph that might be used in a trade publication, annual report, or house organ.

level'' job (as the personnel directors like to put it) with very little training and no proof of talent at all—and if it develops that you are willing to train up from that job, you can do it. And if it further develops that you *do* have talent, that talent and some training can carry you to the highest levels of photography. The range really is that great.

OPPORTUNITIES FOR WOMEN?

Industrial photography is becoming an excellent field for women. Only a few years ago, most industrial photography was accomplished with the comparatively heavy and clumsy larger-format cameras—8 x 10 and 4 x 5—and as a practical matter you had to be young, healthy, and strong—and therefore usually male—to handle a lot of the assignments. An 8 x 10 camera with case and holders could easily weigh 60 pounds, and the tripod another 50. Hauling them up a 40-foot vertical ladder to shoot pictures off the roof could be a real chore; I know—I can still remember once doing exactly that. But with the advent of the high-quality medium- and small-format cameras (more about that in the chapter on equipment), the strong back is no longer a prerequisite, and women in increasing numbers are bringing their special sensitivities and talents to the field.

Again, partly because the small-format camera came first to the public relations field, women gravitated first to the public relations end of the industrial photography spectrum, and that kind of work is still the choice of many. But as the smaller cameras have become more widely used, women have branched out with them, and the world of industrial photography is full of opportunity for the woman who wants to make it her career. And this is true for both the woman who wants the security of a steady job and the one who wants the challenge and excitement of being a freelance.

THE IN-HOUSE PHOTOGRAPHY DEPARTMENT

Companies first started establishing their own photographic departments in order to keep better photographic records of their activities, then discovered that such units could be made to pay for themselves in a great many other ways. It was learned that a photograph could save an engineer hours of time writing a test report, that photographs of company activities could be used to ward off lawsuits, and that the vice-president for marketing liked walking two floors down to the photo lab for his passport picture, instead of making an hour's drive crosstown. They learned that an in-house unit provided better control of proprietary information, and an invaluable library of company data. In recent years photographic units have worked closely with the art and marketing departments to produce highly effective sales presentations, using slides, view-graphs, and even motion pictures. And every day, photographers and photographic managers are developing new ways to make photography contribute to their companies' effectiveness, capabilities, and—most important of all—profits.

A typical photographic unit may be just one photographer who also does all the lab work and keeps all the files, or it may employ as many as forty people. The larger unit is

Not a very appealing picture, true; but the details delighted the corporation's attorney. Photo by Robert Thornton of Northrop.

14

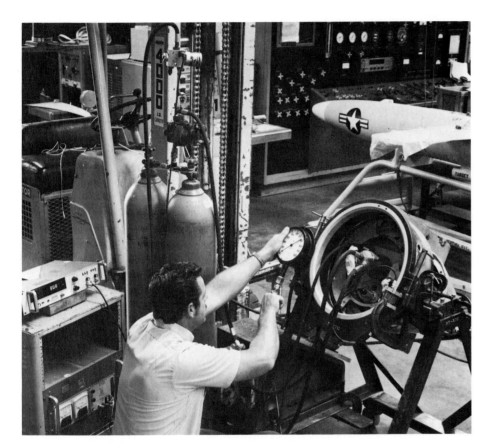

This photograph provides the test engineer with an irrefutable record of the test setup, the kind of instrumentation used, the method of installation, and proof of proper safety procedures. Photograph by Gary Wehr, Northrop Corporation.

likely to include clerical and administrative people to handle the buying of supplies, keep the books, maintain the files, and manage the flow of work through the department. If the company is involved in classified government work, there may be a security clerk to control the files of classified negatives, prints, and slides.

Most in-house organizations maintain their own laboratories, although a few of them—usually the one-person departments—stay strictly with camera work and send the laboratory work to an outside support lab. The companies that maintain their own darkroom facilities do so not just to save money but also to maintain better control over schedules, to protect proprietary data, and to cope with the problems that may be unique to their particular operations.

In the largest such organizations, the photographer may get the opportunity to specialize in studio setups, or portraiture, or public relations work; but in most of them he or she is expected to be versatile and willing to take on new jobs. From the photographer's point of view, the thing that makes the work exciting, and its main challenge, is the tremendous variety of assignments he or she is expected to cover. And that variety keeps growing.

On location in the lower Mojave Desert, staff photographer Gil Nunn tracks the recovery of a space capsule. Photograph by Robert Thornton, of the Northrop Corporation.

THE INDUSTRIAL FREELANCE

There are many companies that have a sporadic but continuing need for photography, yet would find it difficult to support a full-time photographic department. Others that do have photographic units find there are still times when they need the services of an outside photographer, either because the in-house staff is not free to cover some special project, or because the company's management feels it would like to hire an outside "expert" for something like the annual report. The industrial freelance is that "expert."

Because the freelance is so often called upon to take the "outside" assignment, which usually means travel, he or she must be prepared to travel light, far, and fast, and be able to start producing on arrival. The free-

lance must have—or have available—all the camera and lighting equipment necessary to handle the assignments he or she accepts. The people who are equipped to cope with such problems stand at the highest level of industrial photography, and they get paid very well indeed.

Being considered among the glamour people of the field, they sometimes have to deal with the perfectly natural resentment of the in-house photographer, who sees the juiciest assignments going to the visiting hotshot. Because the freelance is sometimes dependent on the house photographer for assistance and guidance while on that person's home turf, the ability to cope with such resentment can be an important factor in the success or failure of the assignment.

The freelance may be sent off to a dozen different facilities of a company, in as many

16

different states, to create in two or three weeks a large selection of illustrative and interpretive photographs for the company's annual report. He or she may even have been selected and hired by the advertising or design firm that is actually assembling the report, and only indirectly work for the company that is being photographed. For some people this can be an exciting and stimulating way to live, and the financial rewards can be substantial. But for others the work pressures and the hectic pace are discomforts that outweigh the glamour assignments and the extra money, and they find they prefer the calmer waters of the salaried job. If you are considering this field of industrial photography, you would be wise to take a good hard look at your own values, and plan your entry into the field accordingly.

Petroleum operations tend to be dirty, but they should not look unlovely in the annual report. Steve Kahn found beauty in these contrasting forms, which he shot on freelance assignment for the Tosco Corporation. Photo © Steve Kahn.

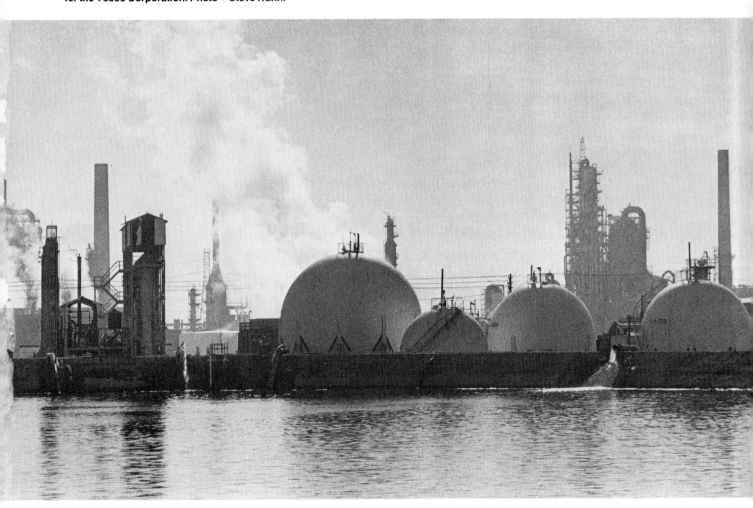

IS THERE A MARKET?

It's a reasonable question. Will there be any jobs in this field next year, or ten years from now? And it deserves a reasonable answer, which is: very probably, yes. Of course, that's the same answer you would get if you asked that question about jobs for bricklayers, or lathe operators, or deputy sheriffs; but there are some important differences, and they do help to make the picture look more encouraging.

Industrial photography is a comparatively new field, and it is still expanding into companies that earlier were slow to accept its value. With some important exceptions—the automobile industry is one—the old heavy industries have been less quick to recognize the value of photography to their operations than the newer "light" industries such as aerospace, electronics, and research-and-development companies. For example, one of the old heavy-manufacturing corporations, based in Ohio, builds transportation equipment and has more than fifty divisions scattered throughout the United States and Canada; it has *one* photographer to cover all fifty-odd divisions. He does *all* the corporation's photographic work, including public relations and the illustrations used in its national advertising. He has one assistant, a person he borrowed from the secretarial pool.

The more sophisticated aerospace and electronics industries, on the other hand, took an early lead in establishing capable and highly functional photographic departments as basic units of their companies, and such units continue to grow and prosper as they continue to grow in their ability to help the company show a profit. In one aerospace corporation, which can be considered typical, there are four major divisions and several

smaller units scattered across the country. Each of the four divisions has its own photographic department, and photographers from one department support the other departments as they are needed.

The home division, with approximately 20,000 employees, has a photographic department of about 40 people, more than half of whom are photographers (the balance being administrators, planners, coordinators, and clerical help). One of the smaller divisions has 6 photographers to support about 900 other employees. All of the divisions are so structured as to be able to call upon outside (freelance) photographers as they are needed. The point is that photography was comparatively late in coming to industry, and it has a long way to go before saturating the market. There are more than 242,000 firms in the United States with annual sales above the $1-million mark, and a very large percentage of them will be a market for industrial photography.

At the same time, photography is becoming more and more an integral part of the manufacturing processes that it once only recorded. Today it is used in the manufacture of electrical components, in chemical milling operations, in all sorts of laboratory analysis procedures, in crime detection and prevention, and in hundreds of other ways not even considered a dozen years ago. And every time photography is used in a new way, in a new procedure or process, the future of the industrial photographer becomes that much brighter and the career itself that much more secure. The work also becomes more challenging; few fields of endeavor require more attention to changing materials and methods than that of photography in industry. At one point a few years back, my staff and I estimated that approximately 50 percent of the

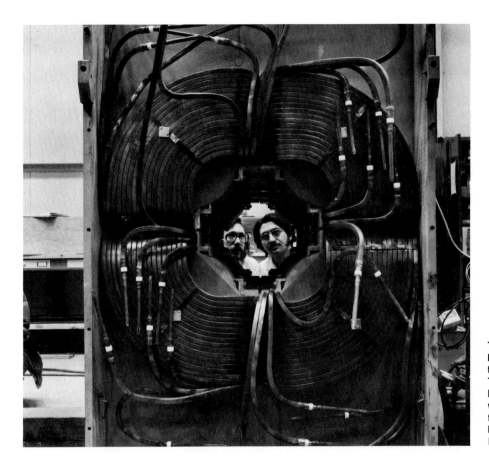

The subject is magnets, but without the people there would be no picture. The setup can be seen here. The final picture would have been cropped for content. Photographed by Bill Jack Rodgers for L.A.S.L.

work we were doing at that time would have been *technically impossible* only 10 years earlier. In *only 10 years*, changes in methods (some of which we had developed ourselves) and changes in optics, chemicals, and films, had made that much difference. Some effort spent in keeping up with the state of the art is necessary in almost any field, but for the industrial photographer it is critical.

CAN YOU QUALIFY?

There is room in this field for just as much or as little as you are willing to bring to it. It is sometimes—though more rarely, now—possible to get a foot in the door with no more than an average amateur's background, and work your way up from there to whatever level you have decided should be yours. The better

the background you can bring to the job, of course, the more jobs will be open to you, the better they will pay you, and the better your prospects will be for increased opportunities and higher salaries in the years ahead. There was a time when most photographers, industrial and otherwise, got their training on the job, from the people who were already there. Today, the better companies have learned that they can save a lot of money and get better photographic support by insisting that their photo departments be managed by highly trained and experienced people, and those managers, in turn, are likely to insist on a proven high level of competence before they'll even put you on board. The chances of your being able to establish that level of competency without some formal training in photography are not all that good. It can be done, but the odds are against it. You need training.

WHERE DO YOU GET TRAINING?

The very best way, the quickest (and sometimes the most expensive), is to spend two to four years in a good photographic school, or in a good art school with a photographic department. Don't overlook the value of some art training; the higher-level photographic jobs require an understanding of the basic art principles of form, design, and color. It is true that some photographers have become highly successful without any special training in either art or photography, and it is also true that Mozart was composing original music before he was eight years old. Some people are born with exceptional talents; but most of us need to go to school.

Another good place to get your training is in the journalism or the art department—it varies with the school—of your state university. Nearly one hundred of our colleges and universities today offer bachelor's degrees in photography. When picking a college for photographic training, it is best to ask a lot of

A good photography school offers hands-on training with the latest equipment. Photograph, courtesy of Brooks Institute, Santa Barbara, California.

questions. Some of them have excellent departments; others treat photography as a poor relation of the arts, or as a minor phase of journalism. You don't want to start out in this field by getting your training in photography from people who do not respect it enough to treat it as a separate discipline.

In some areas, good photographic training can be had in community colleges or technical schools. Here again, it is good to ask questions. Make contact with the heads of photographic departments in the largest companies in your area, and ask them what they think of training available where you live. Most of them will be glad to give you a little of their time, and while a photographic manager will have personal biases just like everyone else, for the purposes of this discussion they will be informed biases, and helpful.

Next down the scale are the correspondence schools, some of which can be quite useful. However, dealing with a correspondence school requires that you have a substantial amount of equipment of your own and an available lab; getting your training this way can be a slow process. A great deal of what you learn during a correspondence course you will have to teach yourself. It can be done, but it is extremely slow, and it is not the best way to study a hands-on craft like photography.

People *have* gotten their training in the military. The obvious advantages of this are that somebody else pays for your training and supports you while you learn, and you may get to work with some of the most advanced equipment available anywhere. The disadvantages are that the training may or may not be relevant to the kind of work you want to do in civilian life, it will include no art training whatever, and it will eat up several years of your life with only a very small part of that time devoted to actual photographic training. On the other hand, if you are already in the military and photography is your field of interest, you should certainly take advantage of the situation.

It is sometimes possible to get an apprentice-type job as an assistant to a working photographer in a commercial or advertising studio, and learn there whatever the photograper has the time and inclination to teach you. The pay will be low and the rate of learning quite slow, but it will get you started. The trap in this is that you may discover after five years that you have not had five years' training, you have had one year's training five times. If circumstances force you to use this method to get an education, you might do well to plan to move from one such job to another at relatively short intervals—say every year or so—in order to be exposed to as many different kinds of work and as many different approaches as possible. It will be up to you to learn as much as you can while you are in each job, and to get whatever art training you can on the outside. Each new job should put you at a slightly higher level, because each time you will be bringing a better background to the work, and that improved background should be worth better pay; however, you may sometimes find it worth lower pay to get a job that offers exceptional work experience.

SUMMARY

Industrial photography is a large, varied, and exciting field of work, and there is good reason to believe that for as far as we can see into the future it will continue to get larger and more varied, and to be an exciting and challenging way to make a living.

There are opportunities for both the pho-

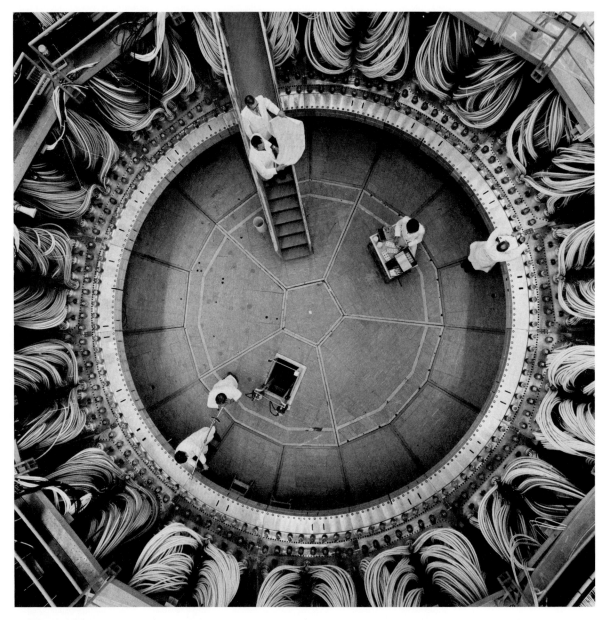

This is one of the things an inventive photographer can do to make a picture out of what from some angles would seem a hopeless jumble of cables and equipment. Photo by Bill Jack Rodgers, Los Alamos Scientific Laboratory.

tographer who wants the security of the weekly paycheck and for the free soul who wants to shoot for the moon. There are jobs here for both the loner and the team player, and if you have both talent and the discipline to make it effective you will find it can be a rewarding field.

Good training is not an absolute prerequisite, but it is much to be desired, and it is available. There are universities, art schools, photographic schools, correspondence schools, the military, and apprenticeships; if you really want good training, you can get it—and you should.

II

Breaking In

In many professions, you can establish your qualifications for your first job by showing that you have a degree from an appropriate school, or that you have passed certain exams required for practicing your profession. An attorney interviewing for a first job, for example, proves that he or she has the necessary qualifications by showing that he or she has graduated from a *recognized* law college and has passed the bar examination. The attorney still has to survive the oral interview, of course, but the technical qualifications have been certified by the school and by the Bar Association.

When you apply for a job in photography, however, either for a permanent in-house job or for an assignment as a freelance, your success or failure hangs almost entirely on your portfolio. You have to show what you *have already proved you can do*, not what you would like your prospective employer to think you *could* do. True, it helps if you can say that you graduated from a good photographic or art school; that says that you have been exposed to good training. And it helps to have good letters of recommendation from people who are familiar with your abilities and your character; the letters show that others think you have the necessary qualifications for the job.

But the bottom line is your portfolio. It tells your prospective employer not only that you have been exposed to good training, but that you understand it and *can put it into practice*. Anything else is just talk, no matter how well-written and supportive it may be. The portfolio is fact, and business people live on facts, not opinions. Therefore your portfolio is the key to your future, and it is worth the best thinking you can put into it.

HOW DO YOU BUILD A PORTFOLIO?

The first thing you put into a portfolio is the impression of competence, of professionalism. Every single picture in your presentation must be—absolutely *must* be—the very best work of which you are capable. Never show anything you will have to explain, never show anything for which you feel you have to apologize. Every single print should be professionally mounted and spotted. Never permit a prospective employer to see a single fingerprint, dust spot, or stain in your work. A good portfolio takes a lot of time and effort to produce, but nothing else you ever do will repay your effort so well. Your portfolio is the essence of your professional identity, and to an

experienced photographic department manager it will tell things about you that you may not even be aware of yourself. You want to be certain that what it tells the prospective employer is what you want him or her to know.

Which brings us to the pictures themselves. What should you include? While there is no pat answer, there are some guidelines. You will want some variety, for example, to show that your capabilities are not limited to one particular type of work. Industrial photography is a highly varied business, and in most in-house operations you will be expected to "double in brass", or operate in several areas, even if you are hired for a specific kind of work. You should include portraits because you might be called upon to photograph the chairman of the board for the annual report. Of course, the portraits you show should indicate that you realize there is a difference between portraits of a rock star and the executive portraits the company is likely to need. Styles do change, even in executive portraiture; your examples should indicate you're aware of that.

This looks like a completely candid shot of the engineers at work. Actually, Robert Thornton arranged the elements of his photograph and directed his "models" very carefully. Photograph, courtesy of the Northrop Corporation.

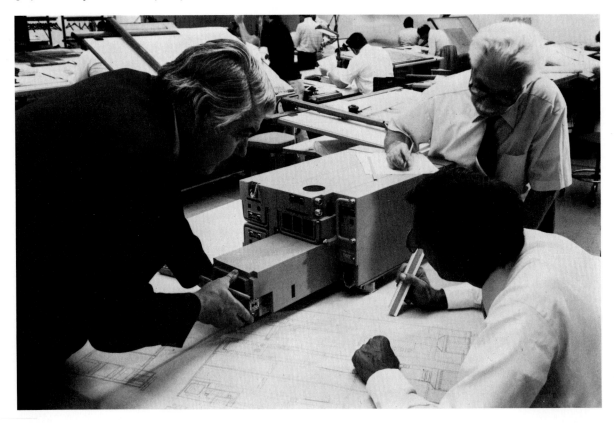

If you have any particular ability in the public relations area, include photographs that indicate you understand working with and photographing people. Good photographers of people are always in demand, especially in industry, where there is sometimes a tendency for photographers to become too hardware/technology-oriented.

You should also include pieces that will show you have an understanding of studio still-life setups, of extreme-close-ups, and of the problems of lighting metals, cloth, and glassware. Your handling of the lighting and optical problems in such jobs will tell a potential employer a lot about your usable skills.

WHAT ABOUT CREATIVITY?

Examples of your creativity may well be the most important elements in your portfolio. Unfortunately, in the last five thousand years of human history, the philosophers, artists, and semanticists who concern themselves with such things have not yet been able to agree upon an acceptable definition of creativity, let alone a way to package it and stuff it into a portfolio. Sometimes it helps to say what something is *not*: Creative photography is *not* colored lights, out-of-focus infrared Ektachromes, Kodalithed portraits, and fisheye

The nature, shape, and size of the parts must be shown, but in a way that makes a publishable photograph. Robert Thornton's setting meets the requirement. Photo, courtesy of Northrop Corporation.

views of the female nude. All of those elements, and a great many more that border on being clichés, have been used in fine creative photographs—but it was the special thinking of the photographer, not the special effects, that made the pictures creative. A creative photograph is one that has a special, indefinable spark that makes the picture interesting and memorable, no matter how simple or hackneyed the subject may be. Sometimes it is nothing more than a new approach to an old subject, an avoidance of clichés. Try to put new thinking into everything you shoot, if you can do it without blowing the assignment.

It should not be necessary to say that creativity is no excuse for sloppy work; if a photograph is a bad picture, it will not help to say that you intended to make a creative statement. The road that is paved with good intentions does not lead to the industrial photographic department.

Because your portfolio is a statement about your professional abilities, like any other statement it should be tailored to your

Whether freelance or staff, the photographer must learn to work closely with the people whose work he is covering. Here photographer Harold ("Bud") Wolford learns from the test engineer what is happening and what he is expected to show in his photograph of a shake table test. Photo by courtesy of Teledyne Ryan Aeronautical.

The problem was to show the nature of the material—which is pretty dull stuff—and make an interesting picture. This is Gary Wehr's creative answer. Photo by courtesy of Northrop Corporation.

audience. This does not mean that to apply for a job in a textile mill, for example, you should stuff your portfolio with pictures of cloth; however, it would not hurt to include some prints that show your understanding of the problems involved in lighting for weave and texture. To talk to an employer in heavy industry, you would want to include factory interiors, if you have them, and anything else that might be typical of the problems you would face in that job. Remember who is sitting across the desk from you, and talk to that person in terms that are familiar. It does not help a prospective employer to know that you do a great job of photographing racing cars if you are being hired to shoot close-ups of printed circuit boards in the studio. Make it easy for the employer to see that you can be

an asset to that particular organization.

Even in this age of enlightenment, there are subjects that may be tabu in one place while accepted in another, and you may have to consider this in assembling your portfolio. Do not include photographs that indicate your political views, unless you are certain those views are shared by the interviewer. Some lifestyles, and pictures depicting those lifestyles, are repugnant to people who disagree with them. If you know that you are going to be seeing someone in the world of art, design, or fashion, and you have some nudes you *know* are good, you might want to include them; but even today there are people who simply do not approve of nudes, and if you run up against one of them in an interview you risk having your other work ignored because

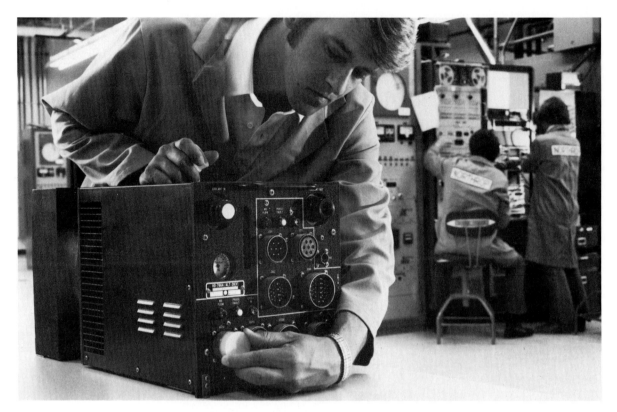

The background was subordinate, but not irrelevant, in this equipment shot by Robert Thornton for the Ventura Division of the Northrop Corporation.

you showed pictures the other person could not accept. I always liked coming across nudes in a portfolio, because I felt they told me things about the photographer I might otherwise have missed. But my reaction may not have been typical, and you should know something about your interviewer if you plan to include figure photography in your presentation.

LANDING THE JOB IN INDUSTRY

Looking for a job can be expensive in terms of time and energy, so don't waste any of either if you can help it. The obvious first step is to discover actual or potential job openings, so that you do not waste your efforts in places where no jobs exist. For that, you can get help.

First, try the want ads in your newspaper. Not all photographic jobs get listed there, but a lot of them do, especially the better ones. Photographic managers like to be able to pick and choose to fill their better jobs, and advertising the job is one way to ensure that. Entry-level jobs often show up in government employment offices, and if you are just starting out you should include these on your list of sources to check often. Commercial employment agencies are a different matter; they do not show a lot of enthusiasm for handling photographers, and I have never known anyone to get a job through one of them.

By the time you have prepared yourself for a job in industry, you will have made a lot

of contacts in the field, whether you realize it or not. The people you buy your supplies from may also deal with a lot of people who are connected, in one way or another, with industrial photography, and they are among those likely to know about it when a job opens up with one of the local companies. The job placement office at your school will sometimes hear of openings, and your former instructors are sometimes good sources of information about jobs. So, also, are any photographers you may have met or worked with, and the people in any local photographic association. Make a point of getting to know the technical representatives of major photographic companies; they get around, and they hear things.

Being unemployed or underemployed is always inconvenient, but it is never shameful, so do not hide the fact that you are looking for work in photography. If you let as many people as possible know of your search, you improve the odds that one of them will turn you toward the job you're looking for.

RESUMES AND INTERVIEWS

It would be wonderful if you could appear in person to talk with every possible employer in the field, but the economics argue against it. One way to cover more ground, and perhaps turn up some interview possibilities, is to mail out resumés. Resumés have been over-used and their effectiveness has been questioned, but they are still worth a try. Most employers get a lot of them. They are usually read, and some are filed for future reference if there are no openings at the moment; others go into the wastebasket. It is worth a little effort to make yours qualify for filing.

Your resumé is like your portfolio, in that it has to speak for you; but while the purpose of the portfolio is to get you the job, the purpose of the resumé is to get you an interview and the chance to show your portfolio. Therefore, the resumé should tell readers those things about you that will make them think it might be worth talking to you in person, without leaving out things that will make them wonder just what it is you are omitting. Remember that the people who will read your resumé read a lot of them, all describing their writers in more or less glowing terms, and they can probably make a pretty good guess at both the accuracy of what you are saying and the importance of what you might be leaving out.

Specifically, your resumé should include your age, marital status, condition of your health, your education, and any experience that is pertinent. Do not include your experience as the editor of your high school paper, or the fact that you were awarded an Air Medal during your stint in the military; you will be asked for things like that on the application you will fill out when you are called in for an interview. Do not get cute with words, printing, or paper stock; hold it to one page, and stick to the facts. If you are a woman, do not hide the fact by giving just initials; people sometimes like surprises, but the interview is not one of those times.

Whether to include a photograph of yourself is a point upon which personnel managers, professional resumé writers, and department managers do not agree. I used to like to see a picture of the applicant, so that I knew what to expect when he or she walked in through the door, but there are employment specialists who disagree with that. (It is illegal for a prospective employer to require that an applicant submit a photograph, as this could lead to charges of racial or sexual discrimination.) Whether or not you voluntarily submit

The problem was to show both the components and their intended use, and that in a photograph good enough to make the annual report. Photo by Robert Thornton, of the Northrop Corporation.

a photograph is something you must decide for yourself.

Once you are satisfied with the wording of your resumé, go over it *very* carefully for errors in spelling and grammar. Despite the fact that you are a photographer, not an English major, it is important that you do this. People who are sloppy about grammatical details are likely to be sloppy about photographic details. Those who hire photographers know that. Get it right. Then get it printed or otherwise reproduced by a good-quality method, and mail it.

Do not mail the resumé by itself. Always include a letter that says who you are and that you are including a resumé, and that you would be pleased to present yourself and your portfolio whenever an interview can be arranged. Address it to the manager of the photographic department—use the exact name, if you can get it. Make the letter direct, specific, and personal, and sign it. *Do not* make up a form letter and type in the addressee's name. *Never* write "to whom it may concern," because letters so addressed do not concern anybody.

A week later, call and ask whether you can come in for an interview. Make yourself available even if the employer indicates there is nothing doing right now and there is no knowing when there will be a job opening. Your purpose is to get the manager to know who you are and whether you can do the work; there might be an unexpected opening to be filled a week later, or some manager friend may call later that same day looking for applicants. Nobody will pass your name along if he does not know who you are.

If you do get an appointment, you will probably be asked to fill out an application before you go in for the oral interview. This is likely to be a long form with a lot of questions to be answered. Here again, don't get cute. Don't fill it out halfway, then start saying "See resumé." Fill it out completely, and tell the truth. I can recall an instance where an employee who was doing a highly satisfactory job was walked off the premises by Security because Personnel had discovered that he had lied on his application. The damaging fact that he had concealed on his application would not have kept him from getting the job, but the fact that he lied about it made his termination mandatory even though his boss made every effort to keep him on. Most large companies have similar rules, and they are absolutely adamant about their enforcement.

It won't do much good to submit a portfolio tailored to the requirements of Amalgamated Brakedrums if you are dressed like a photographer for *The Village Voice*. Tolerance for individual taste in clothing and hairstyles has improved in the last few years, but it does not do to push it when you are sitting across the desk from a corporate interviewer. It should not be necessary to shave off your beard, if your sex and temperament have led you to grow one, but it should be neat; trim it. Your hair need not be crew-cut, but it should be neat and, above all, clean. Your clothing should indicate that you would not find it impossible to fit into the business environment. The photographic manager who hires you hopes that you will stay on the job for a long time; he or she is looking for someone whose professional capabilities will complement those already available, and whose personality will not be in conflict with those of other employees.

At the interview itself, most of your talking will be done for you by your portfolio. The portfolio should be able to speak for itself without a lot of verbal support from you. If asked a question, answer it fully and accurately, but do not volunteer a lot of information about the pictures. Do not show any pictures that you have to explain or make excuses for. Never say how much effort you put into getting a certain photograph; your interviewer probably knows how to shoot such a picture, and you run the risk of making him or her wonder why you found it so difficult. More people talk themselves out of jobs than talk themselves into them. If more information is wanted, you will be asked for it. About fifteen minutes into an interview, I once had decided that I would probably hire the man; an hour later, he was still talking, and I had decided *not* to hire him.

At the end of the interview, either you may get a job offer or the interviewer will

A stockroom is a dull place, but a photograph of one should not be. This interesting shot is by Gil Nunn, for Northrop Corporation.

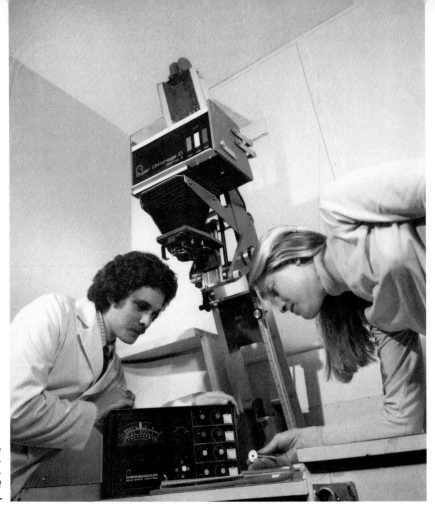

Good photography schools give realistic assignments and provide training on current equipment. Photograph, courtesy of Brooks Institute of Santa Barbara.

thank you for coming in and indicate that a decision will be made after other applicants have been seen. You may still get the job; even when the employer is favorably impressed there may be a commitment to interview others who have called in. Even if the employer suggests that the job is going to another person, don't slam any doors; another photographer may be needed next week, or the first choice may not work out. It happens.

An entry-level job is usually a lab job. In a small commercial studio, at the time of this writing, the starting salary may be as little as $150 a week. In industry, most such jobs now start at about $220 and work up to about $325 or so. As you might expect, the competition for the industry job will be tougher and its requirements somewhat higher.

The lower-level jobs involving actual picture-shooting start around $245 per week in industry and go up to about $415; higher-level positions begin somewhere between those figures and top out at something over $475 a week. An industrial photographer who is promoted to department manager can expect to draw about $100 a week more than one of his photographers. Fringe benefits in the light industries are running about 50 percent; that is, you would have to be making about 50 percent more, if you were working for yourself, to cover the cost of the furnished paid vacations, group insurance, and pension benefits. All of these figures are subject to the wide variations that are typical of wages in photography, and there are photographers making less than the lowest figure I have quoted and more than the highest.

THE FREELANCE

The freelance is actually an independent business person who is engaged in producing photography by the assignment, often under contract, for a business which either has no photographic staff of its own or wants to hire

talents and capabilities it thinks it can't find in its own people. The "visiting expert" syndrome is of great help to the freelance, and he or she should encourage management's belief in it as often as possible.

Because the freelance *is* independent, he or she has more flexibility in the assembly of his or her portfolio than the person who is applying for the in-house job. While the portfolio should still be juggled to match the situation, it can contain the kind of variety that management is willing to concede to the outside expert. If the freelance is applying to a company that has no photographic department of its own, and wants to provide it with general photographic support as required, the portfolio should consist of the conventional prints, either mounted on boards or inserted into an album-type display book. If the ambition is to get an assignment to do an annual report, he or she may bring in only slides, in the blind hope that the office will have a projector and screen available. It usually does, but there is a risk. In addition, if the freelance has done other annual reports, samples of these should be presented.

The freelance's problem is largely one of getting the attention of the right people at the right time—which is as near all the time as possible. In order to attract the attention of those circles where the decisions are made to hire this or that photographer, the freelance must do whatever possible to showcase his or her work. Appropriate showcases are magazines, gallery exhibits, and books—all of which make the people in public relations, marketing, and advertising more familiar with the freelance's name and work.

It would seem logical to contact first the people who make decisions in the company that is putting out the annual report; however, the reality is that photographers more often

come to their attention through the advertising or design agency that has been assigned the overall responsibility for the report. This is why a great many of the photographers who do annual reports are advertising illustrators who were already in contact with the agencies, and who drifted into report work almost by accident. Most annual report photography would seem to bear this out, and the annual report is the one aspect of industrial photography that really offers the greatest opportunity for the photographer to show his inventiveness, creativity, and capability for esthetic expression.

As a business person, the freelance industrial photographer is caught up in the apparent dichotomy of the work. On the one hand, the photographer works for companies that have no photographers of their own. On the other hand, through advertising and design agencies, he or she does their annual report work, which is really a high-level sort of advertising illustration. Inevitably this raises difficulties in pricing because the photographer is working on two different levels. The routine industrial work is usually done on a day rate, which is ordinarily about three times the day rate of a salaried person on the same job, but the advertising work (which is often priced by the agency, sometimes as a percentage of the total price for the report) ordinarily commands much higher fees. As a basis for comparison, as of this writing, the "routine" day rate might be $200 to $450, while the annual report work would pay $1000 to $1750 per day.

The freelances who work on either level—routine industrial photography or annual report assignments—must remember that they are professionals and business persons and accept the responsibilities that go with both. This means calling ahead, keeping

appointments, maintaining schedules, delivering assignments on time, and conducting themselves in a professional manner while on assignment. The greatest talent and capability are only good intentions until they are delivered on time. It also helps to give the *appearance* of being professional, with such trimmings as good business cards, invoices, letterheads, and, invariably, acceptable personal appearance.

SUMMARY

The industrial photographer's professional identity, ''degree'', and proof of qualifications are all in the portfolio. The portfolio should contain the best—and only the best—work that the photographer can do; it should require no explanations, and above all no excuses. Where possible, it should be lightly tailored to the probable interests of the viewer, and it should not contain anything that might be on the interviewer's tabu list.

Being unemployed—looking for a job—is inconvenient but not shameful; let the word get around. Take advantage of your contacts at school, in associations, and in the business. Use resumés, but be sure they say what you want them to say, and follow them up.

When you fill out a job application, tell the whole and unvarnished truth; companies are very touchy about that. A negative item in

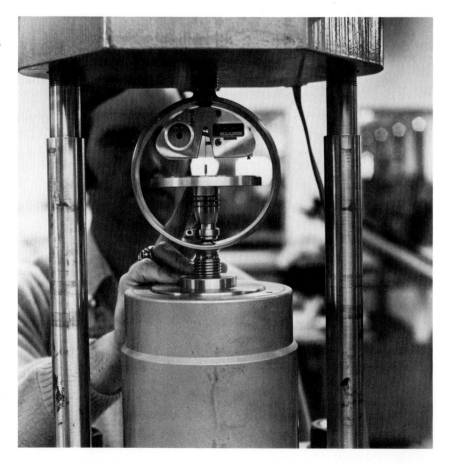

This clean shot of a precision instrument was made by Bill Jack Rodgers of the Los Alamos Scientific Laboratory in New Mexico.

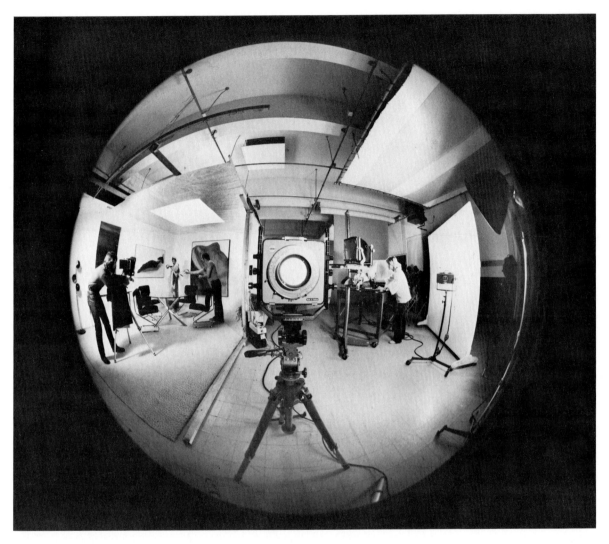

Special lenses give special effects. This fisheye view of students at work on studio assignments was furnished by the Brooks Institute of Santa Barbara, CA.

the application may or may not interfere with your getting the job, but a lie will get you fired eventually.

In the interview, let your portfolio do most of the talking. Answer questions honestly and fully, then stop. What the prospective employer wants to know, he or she will ask. Learn when to stop talking, but don't hold out on the truth when asked a question.

The freelance can take advantage of the ''visiting expert'' syndrome in preparing a portfolio, and this allows for more flexibility than if he or she were applying for an in-house job. For annual report work, the photographer may even use slides. The way to make contact with such work is through advertising agencies or design studios, which usually make the actual selection of the photographer even though the photographer may be paid directly by the company issuing the annual report.

III

Camera Equipment

Any discussion of cameras used for industrial photography will necessarily be general and incomplete. The field is so broad that somewhere, sometime, some industrial photographer is going to need just about any camera in existence today, and in the future will use cameras that are yet to be invented. But, for the bulk of the work being done today, some general conclusions can be drawn and some trends discussed.

CAMERAS

Only a few years ago, professional photography meant using an 8 × 10 view camera, with a slight tolerance for the smaller 4 × 5. With the arrival of high-precision roll-film cameras, all that has changed. The 8 × 10 view camera still has its limited uses, and 4 × 5 cameras are very much in evidence, especially for those jobs that only the view camera will do; but more and more, the bulk of routine day-to-day photography is being taken over by the medium-format and 35 mm cameras. With today's much improved lenses, films, and chemicals, it is possible to produce better images now with the smaller cameras than were made a few years ago with their heavier, bulkier forerunners. The loss of flexibility in the camera body itself has been more than made up for by the tremendous range of lenses and accessories available for the smaller cameras. For those jobs that the smaller cameras will not do, the view camera, with its useful control of perspective and image plane, is retained. (It is worth mentioning that the precision that brought the medium- and small-format cameras to the fore has belatedly come to the view camera, and today's view cameras are capable of far better quality than they once could offer.)

THE LARGE FORMATS

Interestingly enough, the 8 × 10 view camera may be in the process of being rescued from near oblivion (in industry) by the development of the 8 × 10 Polaroid instant color print material. This new development combines the convenience and immediacy of the Polaroid process with the high quality of the 8 × 10 image, producing, in effect, a color contact print large enough to meet most normal requirements. It is likely that the advertis-

The combination of low light levels and some action makes the 35mm camera almost the only choice for situations like this. Photo © Steve Kahn, shot for the North American Car Corporation's 1970 annual report.

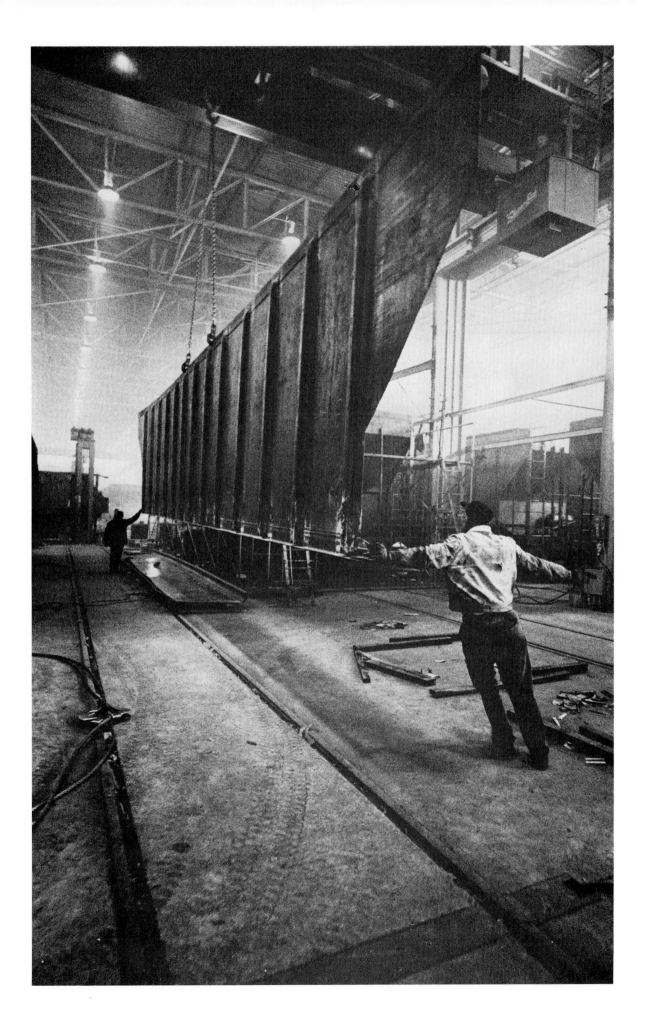

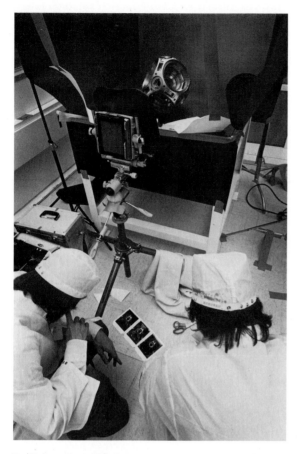

Per Volquartz and his assistant have recorded on Polaroid film three variations in lighting and exposure. Studying these will help them decide how to make the final shot. Photo of the freelances at work made by Robert Thornton for the Northrop Corporation.

ing illustration photographer will benefit more from this development than will his counterpart in industry; but every new material available tends to develop its own new applications, and there is reason to believe that the 8 × 10 Polacolor will do just that.

Probably the biggest single reason for the near retirement of the old 8 × 10 view camera in favor of the smaller cameras was the difficulty of building and using an adequate enlarger. Good 8 × 10 enlargers *were* available, but they tended to be inordinately expensive because of the optical and mechanical problems involved, and they required more laboratory space than most facilities could comfortably spare. Excellent 4 × 5 enlargers are available for a fraction of the cost of the 8 × 10, and the added advan-

tages of smaller size and weight in the field have made the 4 × 5 the standard view camera in industry. It will probably continue to be that, despite the resurgence of the 8 × 10 noted above and the development of some limited perspective-control lenses for the smaller formats.

The Medium Formats

The workhorse camera for today's industrial photographer is the medium-format camera using roll film, interchangeable magazine backs, and a variety of lenses, with a constantly increasing array of useful accessories. These cameras all use 120-size film, but from that film they get a variety of image sizes. There are others, but the most common sizes are the 2¼ inch square (6 × 6 cm) and the 2¼ × 2¾ inch (6 × 7 cm). One medium-format camera manufacturer has recently revived the 1¾ × 2¾ inch (4.5 × 6 cm) image on that same 120 film, but so far industrial photographers have not taken it to their hearts.

Most of the earlier versions of the medium-format camera used the focal-plane shutter, but such shutters were less successful in the larger cameras than they had proved to be in the 35 mm's, and have now given way almost entirely to the between-the-lens shutter with its higher flash sync capability. With the almost universal use of electronic flash today, the focal-plane shutter is limited to synchronizing at speeds of 1/125 sec. or slower—1/60 sec. in some cameras. This one restriction severely limits the use of cameras with focal-plane shutters in the field, where a combination of high light levels and high film speeds can make the slower shutter speeds impractical.

The 35 mm Camera

The 35 mm camera has long been appreciated by the amateur for its obvious virtues—small size, fast lenses, light weight, flexible accessories—but it was not accepted in industry until the last few years brought us appreciably sharper films and lenses. Industrial photographers have always loved the small cameras, but until recently the images they produced simply did not have the quality to compete with those of the larger cameras, and the people who used them were considered not quite professional. (This was true only in commercial and industrial applications, of course; in magazine work and in advertising, the 35 mm came into its own some years ago.) Today the 35 mm, particularly the single-lens reflex version, is almost the standard camera for public relations work, and it is gradually being accepted for other applications even in industry. Its small size, high speed, and remarkable flexibility are making it an increasingly useful tool for even the most critical professional. The flash-sync limitations of the 35 mm focal-plane shutter are no problem in the studio, where light levels can be controlled, and the shutter's higher top speed—usually 1/1000 sec. or 1/1200 sec.—is sometimes needed in the field.

Factors to Consider

Every photographer has a favorite camera, but the professional must approach each job with the flexibility that will permit use of the camera that is the best one for that particular job; and this suggests a discussion of the factors that might affect the choice.

In the studio, size and weight are not serious problems. The camera sits on a tripod, you don't have to carry along the holders,

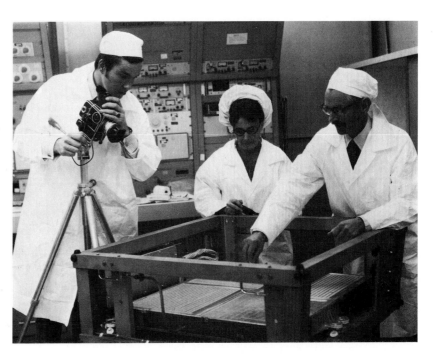

Harold ("Bud") Wolford is dressed up for shooting in a "clean room." He is using a motor-driven 6 × 6 camera for the photoreportage. Photo, courtesy Teledyne Ryan Aeronautical.

Distortion can be controlled by the swings and tilts of this Sinar view camera as Bob Steward, staff photographer, carries out a studio assignment for Teledyne Ryan Aeronautical.

lenses, and accessories, and if you need more film you can step into the nearest darkroom and load a few holders. Thus, the view camera is not ruled out, and it may be the best choice. But there are other factors. If the subject being photographed is one that requires considerable depth of field overall, you may have to use the 35 mm camera in order to hold it. Sometimes it is necessary or desirable to hold critical focus in only one plane of the image. If that plane is parallel to the film plane, it may be possible to accomplish the desired effect with either the 120 or the 35 mm camera; but if the needed plane lies in any other direction, the view camera is the only practical answer.

Sometimes, in spite of the skill level of the photographer and the quality of the equipment, it is necessary to work into a particularly difficult lighting problem by degrees, checking each step with a test exposure. All other things being equal, the view camera wins again, because you can process one exposure at a time without disturbing either the camera or the setup.

On the other side of that same coin, you may have a simple lighting setup but a large number of objects to shoot, each in exactly the same situation. Here the medium-format camera comes into its own, making it practical to shoot and process a large number of shots in a short time.

Even in the studio, there are times when the only possible answer is the 35 mm camera. There are situations in which the extreme depth of field of the very-short-focal-length lenses, or the option of being able to place the camera *inside* the object being photographed, can save an assignment. For extreme close-ups (macrophotography), the 35 mm is almost indispensable.

For field or location photography, size and weight considerations have made the larger camera almost (but not quite) obsolete. The photographic capability that used to fill the back of a station wagon now goes into a carry-on case that you can fit under the seat of an airplane, and almost nobody talks about "the good old days" in industrial photography. In the early days of the space program, photographers would have given their right arms for some of the motor drives that are so popular today. Motor drives are now available for both 35 mm and medium-format cameras,

In a situation like this it is possible to shoot with a view camera, but it is much easier to use one of the smaller formats. For this particular problem, the results are likely to be at least as good. Photograph by Jose M. Ulibarri of the Los Alamos Scientific Laboratory.

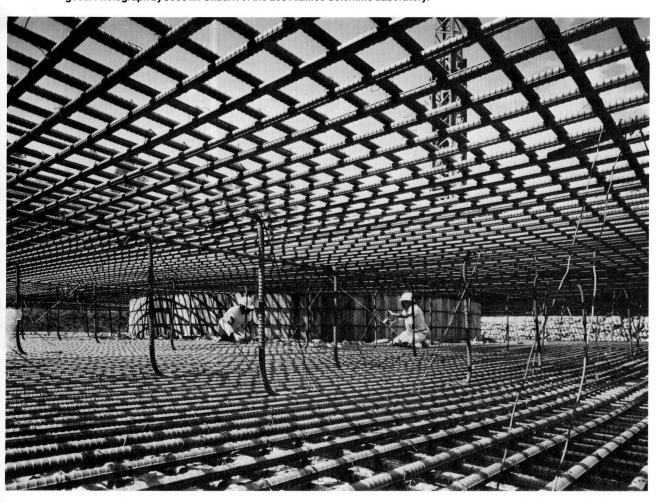

but are more commonly used on the 35 mm; so the 35 mm is the obvious choice for those assignments that require rapid-fire sequences, or for those where events happen so quickly that only with a motor drive can the photographer be reasonably certain of catching the action. For most general field work, however, the larger-format 2¼ inch square (6 × 6 cm) and 2¼ × 2¾ inch (6 × 7 cm) cameras are better, simply because the larger negative is easier for the lab to work with and usually results in the delivery of a better image.

LENSES AND ACCESSORIES

Often the available accessories and lenses will determine which camera the assignment is to be shot with, or whether it can be shot at all. Camera manufacturers have obliged us with an enormous variety of optics and gadgets; some of these seem only to make our work more complicated—others are extremely helpful.

One major use of the 35 mm in industry, even before it became widely accepted for other applications, was for the making of slides for sales/orientation/documentation presentations. While some special "copy stands" were available, the photographer could also simply put the original copy on the wall and shoot it with a standard 35 mm camera. Some photo departments had a lot of such work to do and established more or less permanent copy setups. These were complete with cameras that could be moved toward or away from the copy on sliding mounts or rails, and copy boards that placed the copy on the center line of the camera's optical field and held the copy in place with either a glass cover or a transparent vacuum blanket. Although more sophisticated (and much more expensive) copy stands are now

available, most copy stands are still improvised by the photographer.

But the cameras and lights have changed. The new macro lenses, specificially designed for closer applications, not only produce sharper slides but also come in mounts that will focus the lens as close as 1:1, and at the same time make compensating changes in the effective aperture. This eliminates the need for special adapters for close focusing and special exposure computations to allow for the effective bellows draw effect.

The more sophisticated organizations have also switched over to polarized electronic flash lighting, which further simplifies the exposure problem and results in superior sharpness and color saturation in the slides. The combination of macro lens and polarized electronic flash is today producing a higher-quality slide than was ever before possible, and has contributed to the popularity of the 35 mm slide presentation in industry.

MOVING IN CLOSE

For *really* close shooting, where the image may be the same size as the original subject, or even several times larger, special extension tubes and bellows units for both the 35 mm and the medium-format camera are available. Because of the optical and mechanical limits involved, it is not usually practical to carry the medium-format cameras past the 1:1 image-size range; but the 35 mm cameras perform admirably into the range where the film image may be five to ten diameters larger than the original subject. Optical theory requires that the lens be reversed whenever the image size passes the 1:1 ratio, and special adapters are available for doing this; but for most applications the resulting improvement in image quality is more theoretical than apparent.

For duplicating 35 mm slides, or for copying 120 and 4 × 5 transparencies onto 35 mm film (either positive or negative), there are now excellent copying units that combine the virtues of macro lenses and strobe lights to duplicate translucent copy with a maximum of quality and a minimum of effort. There are ways to improvise setups for such copying, but if you have much of it to do, the factory unit will pay for itself in saved film and time.

Wide-Angle and Telephoto Lenses

The macro lens is only one of a series of developments in the optical end of industrial photography. We now regularly use wide-angle lenses down to 15 mm; these are not fisheye lenses, which also have their place, but true, full-frame wide-angles, with the vertical and horizontal lines corrected. Such lenses not only stir the photographer's imagination toward new kinds of images, they also make it possible to do as a matter of routine some assignments that earlier were just not possible. On the other end of the focal-length scale, there are available—for a substantial price, it's true—good lenses in the 500 mm to 1000 mm range. These, too, not only provide opportunities to stretch the photographer's imagination, but also allow the photographer to shoot pictures of things that were out of reach before.

Zoom Lenses

Between those two extremes—the extreme wide-angle and the long, long telephoto—is the zoom lens. Zoom lenses have been available for a long time; they have been used in the movie and television industry for years, but their optical and mechanical problems had, until recently, kept them from being a serious threat to prime lenses. Zooms just were

not sharp enough for critical work. They are sharp enough now, however, and the option of being able to go from a reasonably short lens to an almost unreasonably long one at one turn of the wrist is making them very popular with photographers—including industrial photographers—who have to work quickly and who cannot always carry all the lenses they would like to have. While there is still some argument as to whether the zoom lenses are *really* as sharp as the best primes—and, given the optical and mechanical complexities of the zooms, they are probably not—they are now sharp enough to be very useful.

Power Drives

The motor drives mentioned earlier have made both the 35 mm camera and its big brother, the 120, faster and a lot more versatile, and they help the photographer keep up in a world where things seem to be happening faster all the time. Actually, there are two different kinds of drives, intended for different purposes and covering two different ranges of speed. One of them, the auto winder, advances the film and cocks the shutter as fast as you push the button, up to a top speed of about two frames per second. The other is the true motor drive, which continues to operate for as long as you hold the shutter button down (or until you run out of film) at speeds up to ten frames per second. With some of these drives, top speeds can be obtained only with the camera mirror locked up, which creates some viewfinder problems. Both winders and motor drives operate on batteries, some self-contained and some with a separate battery pack, and they vary considerably as to weight, bulk, and price. Whether you can take advantage of one at all depends on the kind of work you are doing; and which

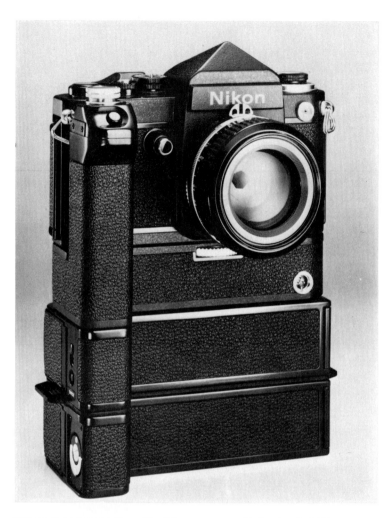

This motor-driven version of the 35 mm camera will shoot up to 9.5 frames per second. Photograph by courtesy of Nikon, Inc.

one you should buy, if any, depends on both the above factors as well as on the equipment you already own. We will talk later about renting equipment; sometimes, for expensive items that you won't be using often, rental is the answer.

THE FREELANCE

The freelance who is supporting the photographic needs of industry in his immediate area has roughly the same equipment problems as the in-house photographer. However,

the photographer who wants to go into the advertising / annual-report end of the business has a special set of problems, most of which relate to mobility. The photographer must match the equipment to the assignment, but because excess size and weight can limit mobility and inhibit effectiveness in a dozen ways, every item must be chosen with those limiting factors in mind. At the same time, any equipment failures are likely to catch the photographer a long way from normal sources of repair and equipment back-up; therefore, he or she *must* have reliable gear, and be able to

44

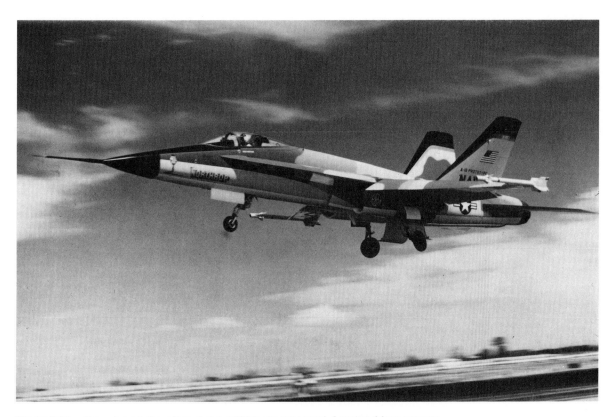

The jet fighter shown here is traveling at about 300 feet per second. A motor-driven camera improves the photographer's chances of catching the plane at exactly the right instant. Photo by Robert Thornton, Northrop Corporation.

cope with breakdowns. Shutters jam, sync cords short out, batteries go dead, and tripods get broken up by airline baggage handlers. Climbing the walls won't remedy the failures; you must have back-up equipment, and the most reliable way, as always, is to provide it yourself. Carry spares of everything you can, especially of such things as sync cords and batteries, and a spare meter to back up the one in your camera. You can usually manage to cope without a tripod, or a particular lens, and almost every professional carries at least one extra camera body. But finding a

particular sync cord in Atlanta or Portland or Tel Aviv on a Sunday afternoon can be a challenge. Remember the Boy Scout, and be prepared.

The nature of annual report photography lends itself to the use of smaller cameras, with the result that a great deal of such work is accomplished with the 35 mm and the 120, with the 35 mm probably having the edge today. High-quality zoom lenses help to reduce the number of separate optics required, and there are other specialty items that help to make the freelance's life less difficult. There are now

In the early years of industrial photography, the weight and bulk of the then-necessary 8 × 10
view camera and its equipment discouraged many women from this work. The tripod alone,
as seen in this vintage shot by Ernest Reshovsky, weighed nearly 50 pounds.

some relatively rigid but extremely lightweight and highly portable tripods, and even some entirely satisfactory tripod substitutes that clamp to other available structures and support the camera.

There are other problems that the freelance is more likely to encounter than the in-house photographer, and most of them relate to the airlines. One reason to reduce equipment weight and bulk to the minimum is the need to get most of it—all of it, if possible—into your *carry-on bag.* Airline baggage handlers are notoriously hard on photographic equipment (I had two expensive tripods broken on successive trips), and they also have a very cavalier attitude toward its destination. *You* may very well land where your ticket says you will, but any luggage that you allow to be put into the hold may or may not arrive with you. It will probably catch up with you eventually—it usually does—or the airline may eventually pay you for the airline's idea of its worth, but that may not be in time to salvage the assignment. It is worth a little of your time to determine just what the airlines will allow you to take as carry-on luggage, and to make certain that all the essential elements of your equipment will fit into that bag. The rules change, but at last report the allowance would permit a pretty complete 35 mm outfit to be stowed under your seat. The airlines will tell you the allowance in dimensions, not in weight.

DEALING WITH X RAYS

You can't quarrel with the airlines' security precautions, but the use of X-ray equipment at airports poses special problems for the photographer whose career may depend on getting the film through without damage. The people who design the equipment, and the airlines, both insist that the X rays they use do not damage film, and for a single pass through the gate that may be true. But film is sensitive to the X rays' cumulative effect, which means that the dosage it gets in the first pass is added to that of the second pass—and the third, fourth, fifth, and sixth, if you go that far. Sooner or later, this will add up to loss of image quality. The situation is worse if you go overseas; some of the foreign installations may damage your film in one pass. X-ray-shield bags for film, made of foil, are available, and some photographers use them; but their effectiveness has not been established.

Here again, the rules change, but generally you can explain your problem to the security attendant and have your camera bag checked manually. Know what your legal rights are in these matters, and politely but firmly insist on them. Keep it courteous and friendly, though; people who carry badges and guns and think of themselves as The Law can be very touchy when they think their authority is being challenged. You are not challenging their operations or their procedures; you just want to pass your film *around* the X ray, and it can usually be done. When you lose a round, and you will, the chances are that the one exposure will not harm your film.

One last word of caution. Nobody knows better than you do that your equipment is both expensive and negotiable. It is highly subject to ordinary theft. It may be good for the ego, and sometimes good advertising, to carry flashy camera cases identified with your name and profession, but it is playing robber roulette with your equipment. Some freelances buy old, used travel cases and build them up inside to carry their gear. It works, even if it lacks glamour. An alternative is to go

ahead and advertise, and carry a lot of insurance; but camera insurance, even when you can get it, is unconscionably expensive.

SUMMARY

Industrial photography is so broad and varied a field that it includes the use of most of the different types of cameras available today, and will later make use of cameras that are yet to be invented.

The 8 × 10 view camera was once almost the only choice for the professional, but it early gave way in industry to the 4 × 5 because of problems with portability and printing. Some 8 × 10's and many 4 × 5 view cameras are still in use today.

The bulk of industrial work now is done with 120 format or 35 mm cameras, which offer greater flexibility and portability. Most early versions of the medium-format cameras were equipped with focal-plane shutters, but nearly all now have gone to between-the-lens shutters for the sake of greater accuracy and strobe-sync capability at higher shutter speeds. The 35 mm cameras are widely used in industry for public relations work, and for the production of slide presentations.

The wider range of accessories and lenses available for the 35 mm and 120 cameras has contributed to their increasing use. Motor drives, special lenses, close-up bellows attachments, all contribute to making the photographer's life easier and more complicated at the same time.

For the freelance, portability is more than just a convenience, and special accessories are available for this. The freelance's problems include airline baggage handling, X rays, and theft of equipment.

IV

Lighting Equipment

For the last fifty years, at least, the photographer who needs to use artificial lighting to make an industrial photograph has had the option of using either some sort of continuous lighting or one kind or another of flash.

TYPES OF LIGHTING

CONTINUOUS LIGHTING

As recently as a few years ago, continuous (tungsten) lighting equipment tended to be large, heavy, and expensive both to buy and to operate; however, recent important improvements have made this equipment much more practical for industrial work. The biggest changes have been in the lamps—bulbs—themselves. The new ones are called tungsten-halogen, or quartz-bromide, or just quartz, and they differ from the earlier ones in two very important respects. They are designed so that they do not blacken as they get older, and they change only slightly in color temperature. Also, for a given wattage, they are a lot smaller; this has made possible the development of smaller and more efficient reflectors, so that the whole unit—lamp, head, and stand—can be lighter and more portable.

Useful life of the lamps is usually given in the 25-to-75-hour range, and you have a choice of 3200 Kelvin for color film or 3400 Kelvin for black and white. The small size of the lamp

Much of industry today is lighted well enough so that ambient-light photography is often the best answer, particularly in such long shots as this one by Bill Jack Rodgers of the Los Alamos Scientific Laboratory.

Lou Jacobs, Jr., boosted the existing light with a photoflood lamp on a portable light stand. This insured depth and clarity in this shot, made on freelance assignment.

also makes possible the use of glass dichroic filters to convert the light to 6000 K for use with daylight-balanced color films. A typical 600-watt bulb is about the size of your index finger, and the 1000-watt bulb is only slightly larger.

FLASH LIGHTING

Flash lamps have changed, too. In the 1930s and 1940s there was tungsten incandescent flash. The bulbs looked like ordinary household bulbs, clear, with foil or wire filling. They could be fired with regular flashlight batteries,

and were discarded after being fired only once. These lamps, and the stands and reflectors they required, were highly portable, and they gave tremendous amounts of light. A No. 2 flashbulb, for instance, was about the size of a 100-watt reading-lamp bulb, and while it lasted—about 1/17 sec.—it was the equivalent of approximately 15,000 watts of light. They are still available today, and for those special situations where you need a great deal of light, they are still supreme.

In some of the older industrial interiors, for example, the existing lighting may be inadequate or of the wrong kind—mixed sources are a common problem. You can set

50

up your lighting extensions on AC with small flood bulbs to preview the effect, then kill the circuit and replace the flood lamps with tungsten flashbulbs. If your extensions don't run more than 50 feet from the camera, you can fire the bulbs with flashlight batteries through the shutter contacts. (Your shutter must be designed for "M" sync.) If your extensions run the length of the plant, you will have to use "open flash": set up the circuit on AC with a switch you can flip at the camera, then open the shutter, fire the bulbs, and close the shutter. Where there is so little existing light

that the big flashbulbs are needed, you can usually get away with the open-flash technique.

Tungsten-flash Kelvin ratings don't precisely match the requirements of "tungsten-balanced" film; so you will need to correct the 600 K difference with a light-balancing filter, probably an 80C; but check your film data sheet—these things change. Blue bulbs that match daylight films are available, and they do balance to the film pretty well, but the blue filter on the bulb will cost you a full stop of light.

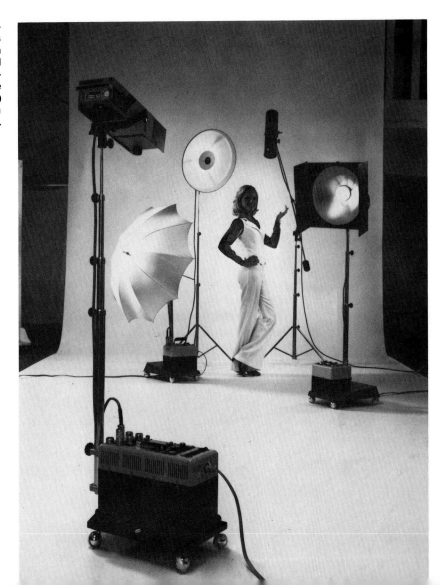

Here is a complete electronic-flash studio setup that combines the power to shoot color at high speeds with a degree of control approaching that of conventional tungsten lighting. (The model is there to show scale.) Photo, courtesy of Norman Enterprises, Inc.

Electronic flash (strobe) came onto the scene around the end of the 1940s; with its short flash time, near-daylight color temperature, and almost-forever lamp, it has almost pushed the incandescent flashbulb out of the picture entirely. In general, electronic flash simply does not produce the same huge amounts of light as the old-style flashbulb. By way of comparison, the largest shoulder-carried electronic portables are rated at about 200 watt-seconds, while the old No. 2 bulb was (very roughly) the equivalent of 6400 watt-seconds. Of course, with today's faster films and lenses, we are usually able to do with a little less light. Electronic flash is becoming more efficient, however, and some of the studio (AC) units now available approach the large flashbulbs in volume of light. In addition, several such units can be slaved to the basic one, and all can be fired, recharged, and fired again in less time than it would take to replace only one of the old flashbulbs. Nobody really misses the old throw-away bulbs very much.

IN-HOUSE REQUIREMENTS

The company photographer who has to equip for both studio and field work will have to study the options available in order to get the most equipment for the budget dollar. If you expect that most of your work out in the plant will involve situations of limited size, and either no workers or workers whose movements you can control, you may want to buy quartz lighting equipment that you can use both in the studio and in the field. If most of your work in the plant must be shot around the people working there, on a noninterference basis, you will have to rely largely on flash in the plant. In this situation, ignore the plant and field when buying tungsten lights, and concentrate on getting those lamps that will be the most useful in the studio.

Select your electronic flash equipment in the same way. If you can see that flash equipment is going to be required for your plant and field work, you may have to sacrifice some of the niceties—and power—of studio electronic flash in order to get lights you can carry with you. Ideally, you should buy both field and studio versions of both tungsten and flash equipment, but in most companies these things must be done one step at a time. The compromise is always influenced by the factors listed above, and a lot of others that may be unique to your particular situation. Usually you should weight your first purchase decisions in favor of portability, and hope that you can get the studio versions later. You can buy excellent shoulder-carried flash units for from $175 up; the most powerful units, equipped with internal slaves and rechargeable batteries, sell for about $600.

PORTABLE QUARTZ LIGHTING

Quartz lighting can be highly effective, and you can carry a lot of it in a fiber case the size of a three-suit travel case. Because smaller quartz bulbs have made the smaller heads practical, one such case will hold four 600- or 1000-watt heads, plus snoots, barndoors, and light stands for all of them. With extension cords and spare lamps and filters this package will not be light, but it can be carried by one person. As of this writing, you can buy such a package for between $600 and $800. This same kit will perform adequately in the studio until you can stretch the budget to buy the conventional spots, booms, and floods on castered stands.

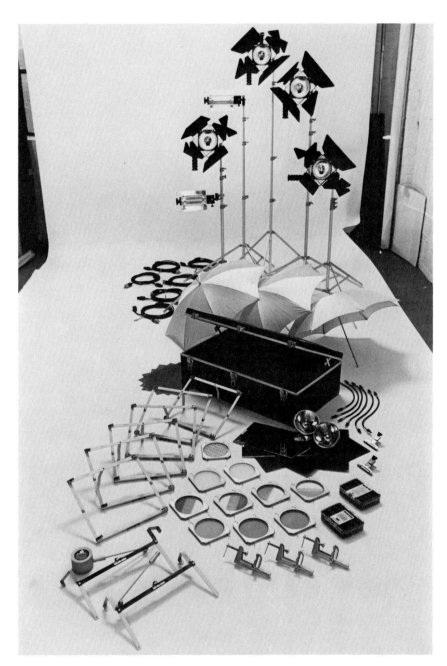

A complete quartz lighting kit for location and field work includes lamps with barndoors, stands, umbrellas, power cords, color gels, filter holders, special-use filters, clips, extra reflectors, C-clamps, and so forth, with a carrying case. The equipment is displayed on seamless background paper, which comes in long rolls. Photo by Russ Lowell for Lowel-Light Manufacturing.

STUDIO TUNGSTEN LIGHTING

This type of equipment is designed strictly for the studio environment, and it does not take well to being hauled out into the field. But in the studio, where size, weight, and portability become unimportant, it still affords the industrial photographer the highest degree of control over the quality of light needed to solve a variety of lighting problems. With spots, booms, scrims, goboes, barndoors, snoots, reflectors, and umbrellas, you can put exactly the kind of light you want exactly where you want it, in the color you want, and in precisely the right amount. You can keep changing it and varying the effect until you are sure that it *is* exactly what you want. There is no other way to do this; which is why, in spite of the

53

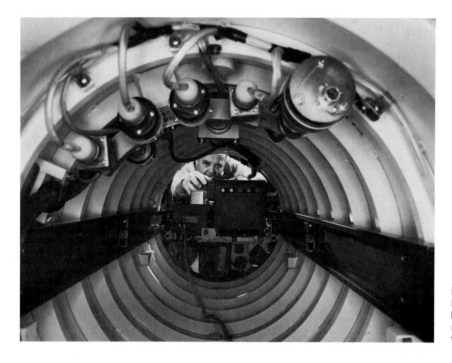

Lighting the man was simple, but lighting the inside of the torpedo hull at the same time required a ringlight. Photo by Robert Thornton for Northrop Corporation.

growing popularity of electronic flash, the tungsten lamp is still very much with us.

This does not mean that the tungsten lamp has not been changed, modified, and improved. We have already mentioned the changes brought about by the smaller quartz lamps: smaller, lighter heads, better spots, more consistent light value and color. The smaller heads make for less clutter, leave the photographer more room to get around, and as a rule are very efficient; even the smaller reflectors can give a surprisingly smooth floodlight, with no hot spots or dull areas. The stands can be lighter, too; and while weight isn't really a problem in the studio, the smaller lights are easier to handle and move about.

STUDIO ELECTRONIC FLASH

Developments in this area have been considerable. The newer units are more powerful and more controllable. The people who made the earlier units used to think it was impos-

sible to replace studio tungsten lighting with electronic flash. For one thing, it was never possible to see exactly what the light was going to do. The experienced photographer could make a fairly good guess, but the inability to know exactly led to some unhappy surprises. In the last few years there have been some important changes in electronic flash designs, and the best of them now incorporate "modeling" lamps—continuous-burning tungsten lamps—that give an idea of what the flash is going to do. However, there are some problems. While the electronic flash itself is adjustable in power, either by the stop or continuously variable, the manufacturers have had difficulty in making the modeling lamps vary in intensity directly with the power of the flash. There are several different methods in use, but I am told that none of them is completely satisfactory.

Earlier models of the spotlight had similar troubles, and to a greater degree. These

problems arose from the fact that the efficiency of the spot depended somewhat on the exact location of the light source, and it was not practical to put the spot and the flashtube at exactly the same point. Recent models have been much improved, and some photographers find them entirely satisfactory. In situations involving people, elimination of subject movement may be more critical than precise control of lighting.

Most of the various types of studio lights available in incandescent are also available in electronic flash—floods, spots, strips, broads, and the ubiquitous umbrellas. Umbrellas are particularly useful because they have the effect of making a broad, soft light source out of almost anything, and in this one case at least it is possible to use a modeling light and know pretty well what the flash is going to do.

Here the photographer is working with an electronic flash suspended from the ceiling, an arrangement that keeps stands and cables off the floor and out of the way. Photo by Henry F. Ortega, of the Los Alamos Scientific Laboratory.

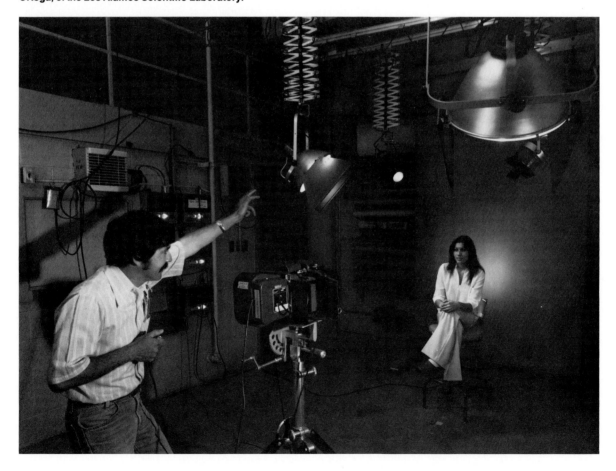

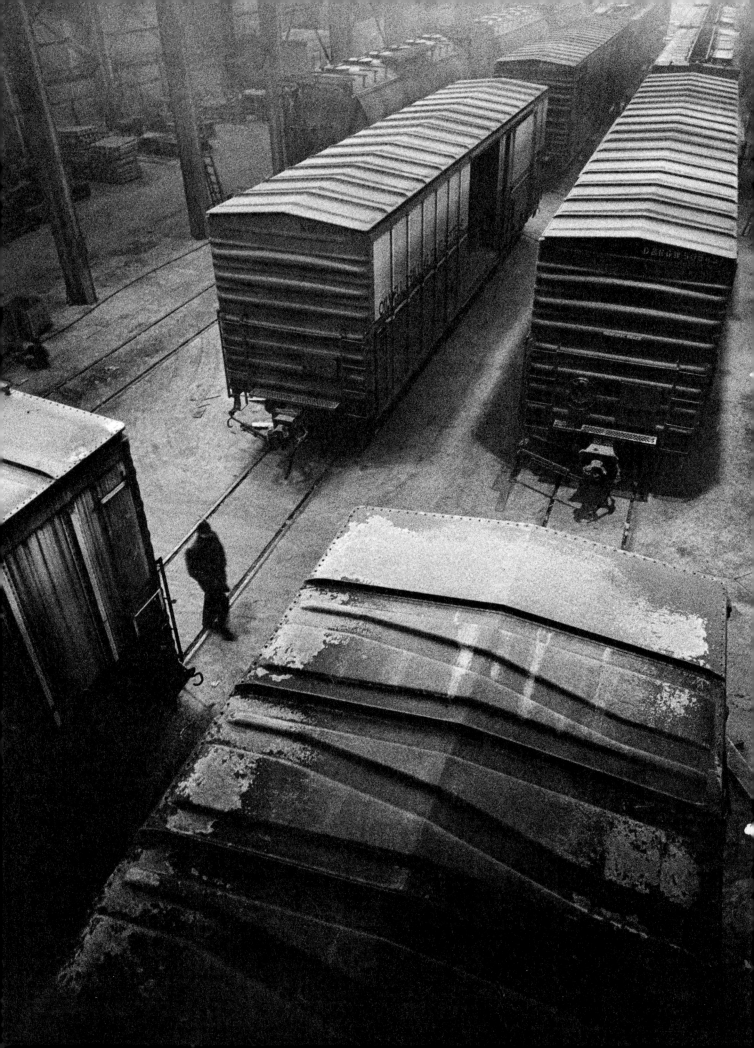

Lighting Systems

Some manufacturers offer systems of lighting that hang from the ceiling, and move on tracks. This has the obvious advantage of keeping light stands and cables off the floor, keeping the floor or background paper clean a little longer, and eliminating the hazard of lamps that get knocked over onto the set or the subject. It doesn't eliminate *all* hazards; until you get used to looking up instead of down, it is easy to bang your head on the hanging lamps. There are two major disadvantages to such systems: The overhead tracks necessarily limit the movement of the lamps, and both the equipment and its installation are costly.

AMBIENT LIGHT

Having good lighting equipment available does not mean that you need always use it. Most of today's industrial plants are very well lighted already, often better than they would be with any special lamps you might bring in. It is true that fluorescent lighting makes for problems with color films, but with a little effort you can match filters to your particular lighting/film combination and save yourself a lot of effort—and just possibly make a better picture. Ambient light, whatever its source, is usually more believable than anything you can substitute for it, and believability is often an important element in photographing a product. This point is made for us in such situations as the printed-circuit room, which is lighted with gold-colored fluorescents; lab scenes, where the lights being used may well *be* the picture; and in such self-lighted situations as welding and the pouring of molten metals. With the appropriate filters and a tri-

pod, you can avoid the hassle of dragging your lights with you on every job.

THE FREELANCE'S LIGHTING PROBLEMS

The independent photographer has all the same problems as the company photographer, except that he or she has to give more consideration to portability problems, and must consider the possibility that an assignment in a particular plant may require special plug adapters and extra-heavy and extra-long extension cables. For all of these reasons, the freelance is likely to rely heavily on flash equipment, and to put more of his or her lighting equipment budget into flexibility rather than control.

For the freelance who specializes in annual reports, the portability problem is even more acute because of the near certainty of air travel. Fortunately, the nature of report photography in recent years has placed much emphasis on ambient-light photography, and the photographer can sometimes shoot an entire annual report without ever needing anything more complicated than a single, portable, electronic flash.

It is also helpful that the manufacturers have developed several very small but very potent electronic flash units that are fully automatic, and have thyristor circuits that conserve battery energy by delivering only as much light as is actually required for each shot. The units are very light in weight, very small, can be triggered as slaves, and are adequate for situations of reasonable size when used with fast lenses and fast films. Depending on features and output, they cost from $55 to $150 each, and you can put a half-dozen of them into a box the size of a loaf of bread.

57

SUMMARY

Like cameras, lighting equipment must be selected and used with all the photographer's needs and limitations in mind. The problems out in the plant, or up in the general manager's office, are not the same as the ones in the studio.

"Old-fashioned" tungsten lighting has been considerably improved in recent years, and it is still the best answer for some assignments. The smaller units now available make possible precise control of tungsten lighting in some plant/field situations. In the studio, tungsten lighting still gives the last word in control; but it may be necessary to compro-

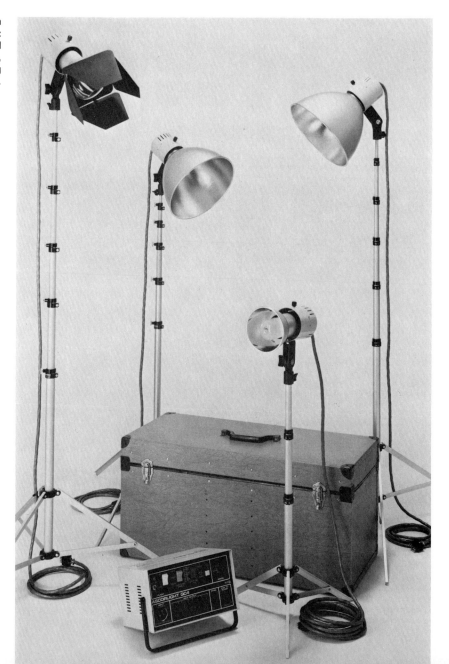

A complete electronic flash lighting kit for location work: Heads, cables, power pack, and stands fit into one case. Photo, courtesy Berkey Marketing Companies.

Sometimes the best lighting for a subject comes from the subject itself. This photograph of glassmaking operations was made by Bill Jack Rodgers of L. A. S. L.

mise on control in order to eliminate subject movement—which means electronic flash.

Portable electronic flash gives the most, and most useful, light per pound of equipment out the door; it stops movement, but it calls for a lot of judgement in use.

Studio electronic flash units now approach the old-style flashbulbs in sheer volume of light, and are approaching—but may not quite have reached—the levels of control available with studio tungsten lighting equipment.

Ambient light is not to be overlooked. With the judicious use of filters and a tripod, it may be possible to do better work without extra lighting.

Where portability is the determining factor, the small, slaved automatics can be lifesavers for the traveling freelance.

Northrop photographer Gil Nunn builds a "tent" of white cardboard. The set is lighted with tungsten lamps, so that he can see exactly what is happening at each step. Photo by Robert Thornton.

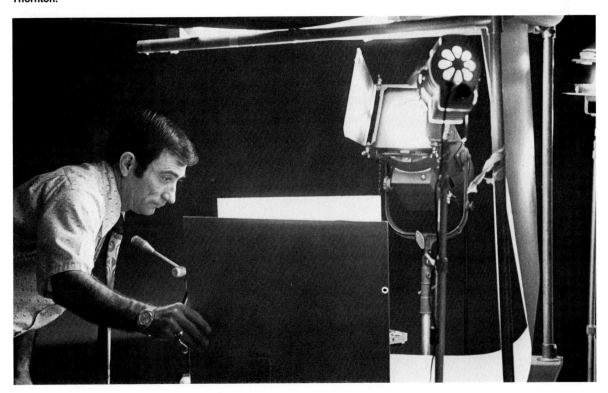

V

The Laboratory

The first thing you should know about a photographic laboratory is that you may not need one at all. This may sound like heresy, but it is a point that should be considered.

A company photographic department should include a lab, ordinarily, for several reasons: quick turnaround on jobs, control of security information, safeguarding of proprietary data, control of photographic quality, specific darkroom products or processes not available outside, and lower cost. Cost is last on this list, because that is where it belongs. Most labs are not in operation to save money, and most of them *don't* save money. They do provide the necessary services and protect data, but they do not—if all the related costs are really counted—actually deliver prints and slides for less money than it would cost to have the same items made at an outside laboratory.

Fortunately for those of us who want to maintain control of the product from exposure to finished image, the cost of the print itself is not often a deciding factor. Ordinarily, getting it in a hurry, in exactly the form you want, keeping it out of the hands of anybody who shouldn't see it, and getting the quality you want, all come ahead of cost.

Even so, once you have your lab established there may be times when you will want to call on an outside lab for support. This will be discussed in more detail later.

LAB SPECIFICATIONS

The size of the lab, once management agrees that you must have one, should be determined by the nature of the work you plan to do in it, the number of people you anticipate will be working there, the company's plans for growth, and the budget. Here again, we *listed* cost last—but now that we have reached this point, that is not the way it works in practice. The biggest single determining factor in the *size* of the industrial photo lab is—unfortunately—the budget. Hard fact of life number one.

How you go about planning the lab, if you are fortunate enough to have that opportunity, will depend largely on whether you can literally start from scratch and design your ideal darkroom(s). More often it happens that you will be given some available space in some unlikely spot, and told to draw up a plan to make it work. Even so, there are some basic guidelines to consider.

60

If your volume of slide work is extremely high, you may want to have special equipment. George Harvan uses this camera to produce approximately 60,000 slides a year. Photo, by courtesy of Bethlehem Steel.

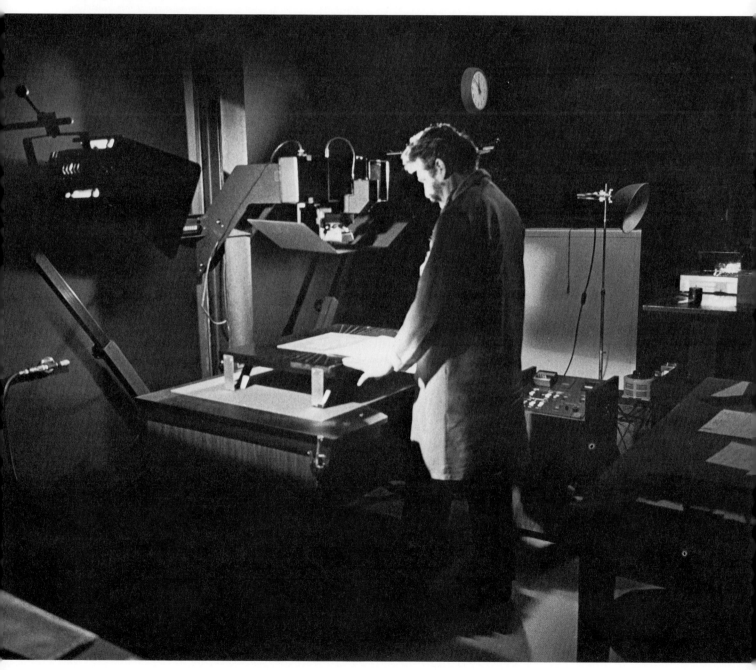

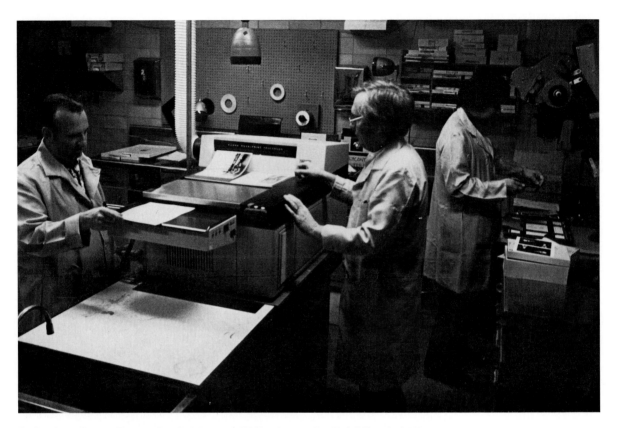

Technicians George Morgan, Ray Smicker, and Ed Mendez use the Kodak Royalprint Processor and five Omega enlargers to produce 100,000 black-and-white prints annually. Photo, courtesy of Bethlehem Steel.

Begin with the functional requirements. Will you be working mostly with roll film, or with view cameras? Will you be doing a lot of color? Slides only, or will you be making color prints? What kind of volumes will you be dealing with in color film, color prints, black-and-white film, black-and-white prints? If you are going to be processing all four of these, will it be necessary to have separate labs, or can you double up? (That may depend on your manpower, too.) Will you have to make room for a process camera and a line lab? Will you be given the budget, now or later, for automatic processors?

If the space allotted for the lab permits, some attention should be given to work flow. If it is practical to wash, dry, and sort both b&w and color prints in a common print-finishing area, both darkrooms should feed into that area. Color and b&w negatives often share a common film dryer; it should be convenient to both darkrooms. The shooting room should be convenient to the film darkrooms, and it should be possible to store all supplies generally near to the places where they will be used.

Ideally, if you have the space and the manpower, and if the volume of work warrants it, it is best to have separate darkrooms for each of the five functions just mentioned. By separating the functions, you avoid some of the chemical contamination, safelight, and scheduling problems—even if the workload and manpower are not enough to keep all of the labs busy all of the time. You *can* process b&w and color films in the same sink, but hold out for separate labs if you can.

SPECIFIC FEATURES

LIGHT TRAPS

Light traps instead of doors are practical only when there is likely to be traffic in and out of the darkroom while it is in use. It does save time to be able to walk in and out without covering up paper or waiting for a print to hit the hypo, but there really are not very many facilities than can afford the extra floor space that a light trap occupies. There are some pre-fabricated light traps that work on the revolving door principle, and they seem to work in less space than the regular light trap requires, but they still cost some space and budget. Think twice before tying up the floor space even such a light trap uses.

SINKS

Sinks are a vital part of your lab; even if you are lucky enough to be putting in automatic processors, you'll still need sinks. They should be selected to match the kind of work you expect to be doing. Normally, print-room sinks should reflect the sizes of the largest prints you expect to be producing regularly, just as the darkroom itself should be sized with that in mind. Sinks in the negative rooms will ordinarily be deeper and narrower than print sinks, and if you don't have automatic processors they can be converted to temperature-stabilizing water jackets by the addition of 8-inch (20.32 cm) standing pipes in the drains.

Sinks may be made of glass fiber, stainless steel, or wood coated with epoxy; all are entirely satisfactory, and there seem to be no really solid photographic reasons for putting one material ahead of the other. The choice boils down to a matter of personal prefer-ences, and to costs, which do vary widely. Stainless steel sinks are noisy, transmit heat and cold, and last a long time. Fiber glass is quieter, conducts heat less rapidly, and is largely impervious to chemicals. Wood sinks are quietest of all, are comfortable to lean on, and are more likely to be built to your exact re-quirements. It is possible to have both stain-less and fiber-glass sinks custom built, but because of the much higher cost of custom work you usually wind up settling for stock sizes.

TEMPERATURE CONTROL

Temperature control is highly desirable for b&w work, and absolutely essential for color. You can stabilize the temperature of the chemicals in tanks and trays by installing a standing pipe in the drain, then running the right amount of hot and cold water to achieve the desired temperature; but this leaves no way of controlling the wash temperature, so a temperature control valve is really needed for each sink. The temperature can be set with an ordinary kitchen-type mixing faucet; but a change in the water pressure on either side of the line can cause innumerable problems. Bite the bullet and put in the temperature con-trol valves, which can then be used to meet all temperature control requirements.

PROCESSING EQUIPMENT

Automatic processing equipment has be-come a fact of life, and there are some very real advantages in having machines process your film and your prints, all temperature-con-trolled, automatically replenished, and dry-to-dry. Machines are more consistent than the best of us in the lab, they don't mind being up

to their elbows in developer, and they leave the photographer free to do more shooting while they do the lab work. Sounds great, doesn't it? And it is, part of the time, but there are some drawbacks you should know about.

First and most obviously, automatic processors cost a lot of money. Your company will want some sort of justification for that kind of an outlay, and it will probably boil down to whether the machine will replace a worker—either someone who is already on the staff, or somebody about to be hired if you don't get the processor. Just telling Budgets that it will save the company money isn't going to get you the necessary approvals; you'll need facts, figures, and proof.

Assuming you do have the automatic processing machine, there are some things about it that the equipment salesman may have forgotten to mention. *Somebody* has to operate it—that is, feed it chemicals, adjust valves, clean it up at specified intervals, shut it down for certain reasons, and figure out what to do when you turn it on and nothing happens (or worse, when you put something in and nothing comes out). These things happen. If the machine works perfectly and consistently, you get "married" to it; and when it *does* break down, the whole organization goes off schedule.

The point here is not to go off the deep end for all the automatic equipment you can get. Ask a lot of questions: What is the maintenance schedule? Where do you have to go to get parts? How much does a maintenance contract for the first year cost? The second year? (You can learn a whole lot from the difference between those two figures, and there

Big industry uses lots of big color prints. Ben Kimura and Bob Stossilavage, color printers, help this unit deliver 50,000 color prints a year. Photo, courtesy of Bethlehem Steel.

will be a difference.) How expensive are the chemicals, and how long do they last? How much is it going to cost to install the extra electrical line, the additional drains and water-lines, the vents to the outside? Will it fit through the door of the lab you mean to put it into, and will it fit inside that lab? What kinds of chemicals does it dump into your drains, and what is the local pollution control board going to say about that? Don't laugh; you may have to answer such specific questions.

Whether any automatic processor makes sense for your particular operation depends on all those factors, as well as others that may be unique to your situation. Probably the most important single question is the amount of use the machine will get. When your volume of printing reaches a certain point, you can probably justify a print processor. If your film processing reaches a high enough level, you may be able to justify a film processor. The machines are capable of doing superior work; that's one thing you don't have to consider. They do require intelligent use, and like computers they can also help you to make some terrible mistakes; but the machines are capable of the best kind of processing.

By way of a case history: One example of recent developments in the field is the Kodak Royalprint Processor (by the time you read this, there may be other similar machines on the market). The Royalprint is a machine that will fit into almost any printing room and re-quires a minimum of extra plumbing and vent-ing. It combines an improved developer-in-corporated paper with special activating and fixing chemicals in a very short, very fast ma-chine process that gives you a dry-to-dry time of less than one minute. And the prints are high-quality, permanent prints.

I have never installed a film processor be-cause the factors I discussed earlier told me that it wouldn't make sense in a lab the size of the one I was operating, but I did put in the Royalprint Processor. The processing time was so short that by the time the lab man could take the last negative out of the enlarger and clip it to the work order, the last print had dropped out, and the finished order could be delivered to the office. Each order could be handed in as soon as it was printed, without waiting for the batch washing and drying times, and without the sorting problems. The short processing time also made it possible to eliminate our time- and space-consuming spare-print files; when you can deliver a new permanent print in five minutes, there's no need for a spare-print file. The machine had been designed to require very little routine maintenance, and by the time I left the organi-zation, we'd had 18 months use from it with almost no down-time at all.

In our case, the print-sorting and spares files were factors that might not have figured into another lab's evaluation of the machine; every lab has its own parameters to cope with, and the decision to buy or not buy *any* kind of equipment should be based on a fully in-formed and thoroughly considered assess-ment of your needs.

ENLARGERS AND LENSES

Enlargers and enlarging lenses are key links between the concept and the print, and the best you can buy is no better than you need; this is no place to save money. While it is sometimes possible to save substantial sums of money on camera lenses with only an in-finitesimal loss of quality, this is for some reason less true of enlarger lenses.

If the budget permits, you should have one b&w enlarger for the larger formats, and a

separate 35 mm enlarger for 35 mm negatives. If you can't buy *good* enlargers in both sizes, buy the larger one, along with separate condensers and lenses for 35 mm work. Don't buy cheaper enlargers in order to have the two sizes.

If you go into color printing, you will require a separate enlarger for it. Good color enlargers have dichroic filters built in for color correction, and highly diffused light sources designed specifically for color work. Trying to use the same enlarger for both b&w and color is very nearly hopeless; if you can't afford separate enlargers for b&w and color, send the color printing out to a lab that does noth-ing else. In the long run it will be cheaper for the company and less damaging to your professional reputation.

Get a *grain-focuser* in order to get the best out of your good enlarger. A good grain-focuser will tell you whether you have purchased good lenses for the enlarger(s); and if the enlarger lenses are not as good as they should be, send them back. Insist that whoever prints your negatives—if that person isn't you—use the grain-focuser *all the time.* There is no point in having a good enlarger with a good lens if everything is printed just slightly out of critical focus.

A grain focuser is absolutely critical to good enlarging work. Photo, courtesy of the Berkey Marketing Corporation, Omega Division.

TRAYS

Trays are important, of course, but they are all pretty good. If you are buying stainless steel, it should be type 316. Some trays of other steels have shown up on the market, and they turn out to be something less than stainless. A good stainless tray will outlast *you,* with only a minimum of care; it will also cost about ten times as much as a plastic tray of similar quality, and weigh three times as much. Steel trays are easier to heat up, and they cool off faster; factors that may or may not be important to you. While some plastic trays eventually become badly stained, that does not affect their usefulness. These are personal choices, and not critical ones.

TIMERS

Everything we do in photography gets timed. Enlarger timers usually reset themselves, so that to make another print at the same exposure, all you do is hit the exposure button. They sometimes have "remote" receptacles,

so that you can use a foot switch and keep your hands free for dodging; they are also usually have to be reset for each use, and time the enlarger goes on, which makes focusing easier. Timers used for developing film usually have to be eset for each use, and they ordinarily are calibrated for longer intervals than the timers made for printing. Some film timers can be used on the enlarger, but you should be aware of their limitations. Most film timers have some sort of warning bell or buzzer to alert you to the end of the timing cycle.

While the little spring-wound timers are impractical in the print room, they are handy for timing other operations throughout the lab, such as mixing, washing, drying, or anything else that needs timing.

ANALYZERS

Analyzers are available for everything from simply telling you the correct exposure for a black-and-white print to giving you the complete filtration and exposure evaluation for a color print. For color they are almost a cast-iron necessity, and for b&w they can be a great convenience. The most recent models can be plugged directly into the enlarger, so that they work somewhat like the automatic camera; you feed the analyzer the data about what kind of paper you are using, push the exposure button, and the timer shuts off the enlarger when the paper has been properly exposed. Because so much of what makes a good print is necessarily subjective, you sometimes have to second-guess the machine, but it can save you a lot of paper. Most such devices have some sort of override provisions, and all of them should be treated as very useful but not particularly bright. There is

an old gag that says that to teach a mule anything you have to be smarter than the mule, and the same applies here. If you're going to use sophisticated analyzers and timers in your darkroom, you'll have to do the thinking; the machine reads and computes, but it won't think for you.

THERMOMETERS

Thermometers are not too exciting, as a rule, but they can complicate your life. A thermometer that is off by two degrees either way (and a great many photo thermometers are) isn't really going to upset your darkroom routine if it is the only one you use and you adjust to it. But if you have one that is two degrees high and another that is one degree low, you can get into a lot of trouble by using them interchangeably. It is a good idea to have one good master thermometer, and check all others against it. If you find one that is off enough to matter, either take it out of circulation or use it out in the office, where a degree or two will not make any difference.

Digital (electronic) readout thermometers are impressive, sensitive, and expensive, but less utilitarian than the conventional types, and somewhat more subject to failure.

FILM DRYERS

Film dryers do not have to be complicated, although some of them are. You can buy them or make your own. The basic requirements are a dust-free place to hang your film, and a fan to remove the moist air so that the film will dry. There should be a filter over the air intake to prevent dust from being drawn in and deposited on the film. Whether or not to use a

heating element is highly debatable. If you need or want to see the results in a hurry, you may prefer the heated dryer; but there are those who strongly object to the use of heat on their negatives. There is some evidence that grain size may be affected by heat, although whether raising the air temperature by ten degrees can make a difference might be worth an argument. Both kinds of dryers are available, including some that actually dry the air with a desiccant before blowing it past your film; such dryers avoid the heat problem, but they are quite expensive.

PRINT DRYERS

Print dryers have developed a new problem with the introduction of resin-coated (RC) papers. The old standard belt-and-drum dryers cannot cope with the RC papers, which must be dried in the new "air impingement" type of dryer. This type of dryer, in turn, will not work for the conventional paper print. At present, a number of labs are using both kinds of dryers, which is a nuisance; if you are about to set up a lab, you may want to look into ways and means of settling on only one kind of paper base. It has been suggested that the major suppliers of paper may eventually discontinue the old fiber base entirely; because developments in this field are quite rapid, the availability of the two types of paper may have changed by the time you are ready to make a decision.

Both types of dryers come in a variety of sizes and capacities, and your choice should reflect your actual needs. Some drum-type dryers come heated with either gas or electricity; availability and prices of the two kinds of energy may influence your choice.

THE LINE LAB

Cameras that are designed for reproducing flat art and making high-contrast-line or half-tone negatives are called "line" or "process" cameras. They are also used in the production of printed-circuit electronic equipment.

With its big process camera and its outrageous film sizes, the line lab is a whole separate problem for the industrial photographer. The darkroom part of it will probably be the largest in your operation, simply because of the large film sizes to be handled. The camera itself may be 12 to 18 *feet* (3.66–5.49 m) long, or longer, with the film-loading end of it built into the wall of the darkroom.

Almost more than in any other place in your operation, you need to be able to look ahead—for several years, if possible—before you even begin to look at equipment or to design the line darkroom. The relationship of your lab to the print shop, and to the blueprint operation, can be a determining factor; whether you will be supporting either or both of those operations will determine the kind of camera, the size of your darkroom, and whether you need to consider a lithographic film processor as part of the installation.

You must also consider the degree of precision required in your camera for support of other operations in the plant. The need to support printed-circuit production or template-making can strongly influence your choices of both size and precision in the camera. If the print shop prints only one color at a time, you can provide halftones with a minimal camera; if it goes into process color, you will need better equipment—and a better operator. If it goes into printed-circuit negatives, you must talk about precision; these things change, but the last time I had to face the

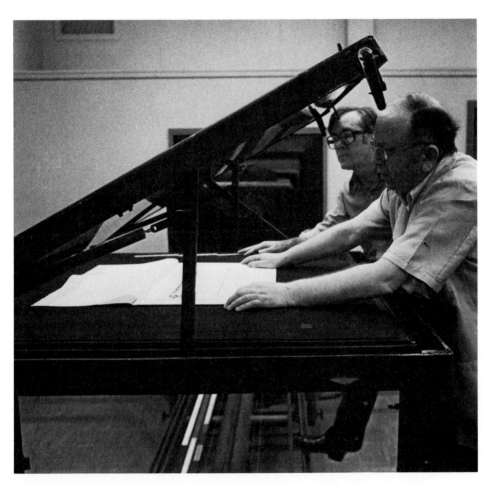

Copy cameras are really big, and take up lots of space. Here, under the supervision of Carl Spangenberg, department supervisor, John Hughes loads the copyboard of the camera, which is built into the wall in the background. Photo, courtesy of Bethlehem Steel.

problem I was being asked to hold accuracies within .0005 inch in 10 inches (.00127 cm in 25.4 cm) on all four sides and across the diagonal of the image. Not every line camera will do that.

LITHO-FILM PROCESSORS

Lithographic film processors, for automatic processing of line and halftone films, are solid and reliable; and they cost a lot of money. The determining factor here is volume, although machine processing is highly desirable for any kind of halftone. If the machine can replace one worker, or eliminate the need to hire one, you can probably justify its purchase. But the decision is likely to be made on purely economic grounds, because the machine actually cannot do anything that a good line-lab technician can't do—it just does it faster and more easily. Line processors vary widely in size and capacity, and the correct choice for your operation will depend almost entirely on your anticipated volume.

LAB MATERIALS AND METHODS

In industrial photography you will use the same kinds of film, chemicals, and papers that are used in any other kind of photography, but there are some economic factors to be considered here that you might have chosen to ignore elsewhere.

In industry, the cost of labor is by far the largest component in the total cost of a photographic negative or print. That may seem obvious, but the economic reality of that statement goes beyond the obvious. Overhead costs associated with an hour's labor—fringe benefits, general and accounting costs, occupancy (your share of the rent)—all are added to the basic cost of labor to figure the actual rate to be used in all computations of labor cost. Just to have a nice round figure, if an employee's salary is $10 per hour, the total

The print-finishing room is laid out to accommodate the sizes and numbers of prints that go through it. Here, Carl Spangenberg and his assistant, Hal Simmons, inspect one of the 100,000 prints their black-and-white department produced last year. Photo, by courtesy of Bethlehem Steel.

Engineers, writers, and artists will be depending on your prints and negatives for years to come. Your lab methods, materials, and procedures must guarantee the permanence of the photographic records you create. Photograph by courtesy of the Northrop Corporation.

cost to the company is usually computed to be somewhere between $25 and $30 an hour.

In your home darkroom, if you have to remake a print because a new box of paper turns out to be a half-stop faster than the one you have been using, you consider that you are out the cost of a sheet of paper. In industry, the remake may involve fifty or a hundred sheets of paper, plus the operator's time at that inflated rate we just discussed. So the economies realized in buying cheap, off-brand supplies can be very quickly eaten up in wasted labor dollars. This is especially true in line labs, which are a favorite target of the accountants because even a small lab can go through thousands of square feet of film a year; and cheap film can cost you thousands of dollars in remakes and opaquing.

I mention this because in industry there is

sometimes a problem with accountants and procurement people, both of whom are price-oriented because that is what they are paid to be. You may be forced to justify your choice of the better-grade films, papers, and chemicals; and, if you don't want to be hampered by junk materials, you should be prepared to prove your case with solid figures.

At the same time, because you *are* spending substantial sums of money, it is important that you buy intelligently. Order your supplies in the largest increments that you can be reasonably sure of using up before they go out of date. If some suppliers send you short-dated or even out-of-date materials, send them back, or negotiate a settlement to your advantage. Here again, buying the best brands will help; top-quality film that *does* go slightly out of date when you inad-

This is the elaborately equipped darkroom of Tom Carroll, freelance photographer of Irvine, CA. In the middle is the print dryer; at the near right is a color-print processor; next to it are temperature-controlled sinks, with timers and safelights; aginst the left wall are two Durst enlargers. Photo by Tom Carroll.

vertently overbuy may still be better than brand new material from a cheaper source.

If you use color, get a freezer or a refrigerator so that you can buy reasonable amounts of color material *in one emulsion number,* to cut down on the losses due to emulsion changes—particularly in the color printing room.

Store all supplies where they will remain cool, dry, and clean, and set up a system that assures that the oldest materials are used first. This is particularly important with liquid chemicals, and you might want to establish a pattern of dating all the chemicals as received. Use a big, waterproof felt pen, and put the date where it cannot be missed. In the darkroom, never, never, *never* put any liquid chemicals into containers that are not adequately identified and dated.

Companies depend on their photographic records, sometimes for a long time, and you have a moral obligation to see that your work is as nearly archival as you can make it. That does not mean gold-toning all the prints, but it does mean using fresh chemicals, testing them as necessary, and being certain that washing times are adequate and that your procedures preclude contamination

of either chemicals or such things as dryer belts. And never store stabilization prints with conventional prints or negatives.

THE FREELANCE LAB

The freelance's lab may vary anywhere from the full-service kind we have been discussing to none at all, with full dependence on outside services. The independent businessperson can go either way; the balance between what is done in a photographer's own lab and what is sent out will depend on the kind of work the freelance is taking in and the availability of adequate support from service labs in the area.

The freelance who concentrates on annual report work may rely entirely on service labs. In most major cities there are good custom labs that cater to the freelance professional, and some of them are good enough that the freelance may be able to rely on them exclusively.

SENDING FILM FOR PROCESSING

If this is the way you choose to go, you will need to learn what there is to know about

shipping times and methods, insurance costs, and the locations of the fastest and most reliable labs. Labs vary in all of the characteristics that distinguish good from bad; short of experience, some of which may be pretty bitter, your best guide is the advice of other professionals. You will hear horror stories from all the pros—mostly true—but there are good labs, and older hands will know where they are.

Depending on where you happen to be when you need to send film in for processing, you may be forced to depend on the United States Postal Service, or you may have a choice between it and one of its competitors. The rules and the rates change for both the Postal Service and the alternatives; know what they are, and when it is to your advantage to use one or the other. You will always want some assurance when you ship film that it is likely to reach its destination, and later you will want to know that it arrived. You can think of insurance not so much in terms of how much you will be reimbursed if your film goes astray, but as assurance that somebody will be keeping an eye on it to see that it does, in fact, arrive safely.

A part of that is up to you, of course; properly packaging and addressing the parcel will help. Envelopes provided by some labs are not exactly indestructible, and some professionals put their names on each roll of film first, then seal all the film in a plastic bag that goes inside the outer envelope.

SUMMARY

Decisions regarding the size and type of lab should be made after considering all options, including that of having no lab at all.

Space and budget considerations may limit you to one lab; sending the color work out may be preferable to mixing color and black-and-white operations.

Light traps represent an inefficient use of space, but are sometimes desirable because of traffic problems.

Choice of materials in sinks and trays is mostly a matter of personal preference; most are good.

Automatic processors are efficient and reliable, but usually can be economically justified only if they replace lab personnel.

Good enlargers and superior lenses are critical to good printing. Separate enlargers are required for b&w and for color work.

Both b&w and color analyzers will save you time and materials, but they will not replace the judgement of the printer.

Film dryers can be simple or complicated, cheap or expensive, home-built or highly sophisticated. They all work, but some do it without heat.

Print dryers now have to cope with both RC and conventional papers, and so far, no one dryer does both satisfactorily. Options may be limited later by decreased availability of the conventional papers.

Line labs are large and expensive. Litho film processors reduce the space requirement, save time, and do good work; and they cost a lot of money.

The high cost of labor in industry will be a factor in your choices of materials and methods, and you may have to explain this to Procurement.

The freelance may not need a lab of his or her own. A good service lab can be important, and the advice of other professionals can be the best guide in selecting one. Films shipped to and from the lab will arrive sooner and safer if you select the right carrier and package the film properly.

VI

Location Problems

The word "location" is usually associated with the movies or, in still photography, with advertising illustration, but a great many industrial photographers also cope with location problems. Going "on location" means picking up your gear and going to some other place to shoot pictures. The photographer for a furniture manufacturer travels to places where the furniture is in use to take pictures of it. The petroleum company photographer may journey to the North Sea to take pictures of a new drilling rig, or to the other side of town to cover some minor refining process. For the freelance, of course, every assignment is on location.

PREPARATION

Every location assignment has its own unique problems, but all of them have certain things in common. For one thing, you are away from home base and cannot walk into the next room for equipment that you forgot to bring. Anticipate as many of the problems as you can, and be prepared for all sorts of contingencies. *Expect* that the engineer who called in the order has underestimated the amount of shooting by a factor of five; ordinarily, your guess will be closer than his. *Expect* that your sync cord(s) will short out, and carry spares. Plan to replace batteries in mid-shooting, to replace extension cord adapters, to have tripods come apart, and to have shutters jam; these things happen, usually when you least expect them. The fact that a camera has never failed you in the six years you have had it just means that it is overdue, and may go any minute. The same advice goes for electronic flash equipment, film magazines, and every accessory you own.

If the customer who called in the order says he or she will need only black-and-white, always take along some color film, and be otherwise prepared to shoot in color. If the customer insists, on the scene, that all that is required are a couple of quickie Polaroids, make them, but back them up with conventional negatives. The customer may genuinely believe—perhaps correctly—that there will never be any further need for those images; but the odds are very good that sooner or later *someone* will want them, and you will be ready to cope with that. Half your problems on location come from having to outguess your customer, and you learn to be very good at it.

In a small company, going on location is administratively simple; somebody hands you a company credit card and keys to the company car, and you are on your way. As companies get larger, the accountants take over, and it gets more and more difficult for a photographer to simply get up and go. You have to work your way through the routine of filling out travel requests, collecting approval signatures, having travel orders issued, and making your hotel and plane reservations through the company's travel agency. Learn what the routine is, and how to accomplish it in the shortest possible time, or the event you are supposed to cover will have come and gone by the time you crawl out of the paperwork.

Start early, as soon as you suspect you are going to make the trip.

When you travel some distance from home base, and you are on an expense account, always take enough money with you to cover emergencies on the assignment. You *will* have emergencies, and cash money is the best single cure for many problems. You may have to call a local photographer at his home on a Sunday evening in an attempt to locate a special piece of gear you need, or even more film; cash will help you get it. It is always easier to show why you spent the money than to explain why you did not get the pictures. The job comes first; you can count the money later.

Going on location may require assembling a great deal of equipment. Tom Smalley makes one last check of his gear before leaving to photograph a test site in the desert. Photo by Robert Thornton for the Northrop Corporation.

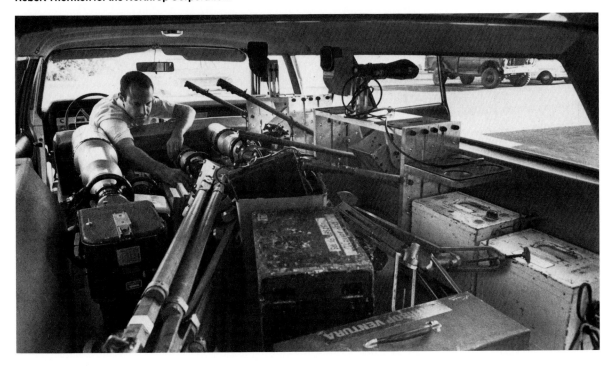

The Contact

Your contact on the location, civil or military, can be the key to a successful trip. There will almost always be someone already there who can answer questions, help make arrangements for your shooting, and keep you from walking in cold on a job that *cannot* be done. In this day of instant communications, it seems impossible that the home office would not know what is going on at one of its outlying facilities, but it does happen every day. Before leaving on any assignment, try to find someone on the scene who can be your liaison with the location problems and personnel. Such a person can be especially helpful if it is necessary for you to make your own arrangements for housing, food, and transportation. He or she can also warn you that the particular gadget you are going down there to shoot won't *actually* be ready for photography until next Tuesday, even though the home office has assured you it would be ready today. You can save a weekend of your own time, and some money for the company, by not leaving until Monday.

OFF-SITE LOCATIONS

There are actually three different kinds of locations that concern the industrial photographer, and they make for different kinds of problems.

Off-site shooting in another plant of your own company, or in the plant of some organization your company does business with, is not very different from working at home base. You still have electricity, heating and cooling, all the amenities of civilization.

If your location is in another company's facility, and that company has its own photographic department, your first order of business should be to introduce yourself to the head of that department—a simple matter of professional courtesy. Let it be known that you are there on *your* business, not to get in the way of anyone else. If you handle things properly, you should be able to count on receiving any help you may need in handling your assignment. At the very least, you can expect a warning that the assembly line shuts down at 11:30 for lunch, or that all the electrical outlets in the shop you are shooting require three-way twist locks, or that you cannot use incandescent flash in the paint department because of the explosive atmosphere hazard. Pick this person's brains; he or she is there all the time, and knows things you don't know.

OFF-SITE LIGHTING PROBLEMS

It is one of the immutable Laws of Industrial Photography that the *big* lighting problems are most likely to come up on location, away from your home base. Large areas with mixed light sources give the industrial photographer the biggest headaches, particularly when the assignment calls for shooting in color and with a large-format camera. (Trade magazines sometimes specify large-format transparencies exclusively.) Typically, this may mean coping with incandescent light, fluorescent light, and daylight all in the same shot. Sometimes it is possible to overpower the existing light sources with a series of electronic flashes slaved to the one at the camera, and hope that the short exposure time will prevent too much contamination of the color by the ambient illumination. For this particular problem, it is sometimes practical to fall back on the old incandescent flash, with its tremendously high output.

Lou Jacobs, Jr., was shooting an annual report freelance when he made this photograph of rebars—reinforcing steel. Locations like this have special hazards, and it pays to ask questions before you go too far afield.

Another alternative is to use a special filter to match the film to the strongest of the existing light sources, and hope that the other sources will not distort the colors too much. With fluorescent lights this is sometimes practical; but if your maverick light sources are mercury vapor lamps, the problem is effectively insurmountable, and the best you can do is use daylight film and settle for whatever that gives you.

Loading the area with portable quartz lights may be feasible if the existing-light levels are low enough. You may even want to experiment, if your color requirements are not too rigid. One photographer on my staff once added unfiltered quartz lights to the red-deficient fluorescents, then shot the scene on daylight film. His reasoning was that the fluorescents were short on red, and the quartz lights would be too red for daylight film, so

Annual-report work can take a photographer a long way from home. Steve Kahn traveled to England to make this shot on freelance assignment for Computer Automation, Inc. Photo © Steve Kahn.

they ought to balance each other out. While the reasoning was rather unscientific, the results were quite successful. Sometimes you will be backed into a corner and anything is worth a try.

If the "contaminating" light is daylight, it is sometimes possible to arrange to shoot the assignment at night to avoid that particular problem.

In extreme cases, where the budget will stand it, you might want to rent movie-type flood lamps. Some of them put out enormous amounts of light—4,000 to 10,000 watts each—and require the rental of a special generator for their operation. This is not a normal solution for your everyday problems, but one to keep in mind for the assignment that cannot be done any other way.

If the best solution that you can arrange still does not provide you with enough light to shoot the job the way you wanted to do it, it

may be necessary to compromise on the film size for the sake of the faster lenses you need. For optical reasons, going from 4 × 5 cameras to 120 formats will usually get you one to two stops, and you can pick up two more stops by dropping down to 35 mm. Beyond that, you can push-process the color film. Each step of this process will cut back on the quality of the image, so don't go any further with it than you must. But even in industrial photography, the very best image *that you can get* is sometimes made with the 35 mm camera.

There is one other problem connected with large-area lighting. If the situation includes any dust or moisture in the air, try to

Locations like this are bad for your equipment; you must take steps to protect it from dust and contaminants. This shot was made for the Flying Tiger Line's annual report by Steve Kahn. Photo © Steve Kahn.

78

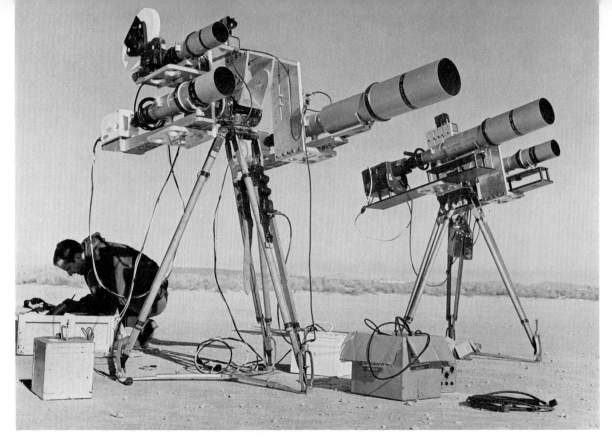

A typical two-man test-site setup involves a great many pieces of equipment, all of which must function perfectly if the photographer is to get the results he seeks. Much of this equipment was rented, and the photographer checked and double-checked every piece before he left home base. Photo by Robert Thornton for the Northrop Corporation.

use crosslighting as much as possible: Light that is directed toward the camera will exaggerate the atmospheric effects of dust, and a flash fired from the camera position will give you the effect of shooting through smoke; either is fatal to good color.

FIELD LOCATIONS

Field locations are different from those that are merely off-site; on a field location you may be miles from the nearest electricity, flush toilet, or telephone. The problems that call for shooting in the field often, though of course not always, involve hazardous or unpleasant things with which you will want to avoid making direct contact. Dangerous chemicals and explosives, for example, encourage the use of long lenses, or remotely operated cameras, or both. On field locations, you must be equipped to operate without the back-up of

your lab and studio, or even electricity; you may also have to rent special cameras, lenses, motor drives, and radio-operated remote shutter-trippers.

RENTING EQUIPMENT

If you have determined ahead of time that the assignment is going to require any such rented equipment, be sure that you personally (or someone on whose judgement you can depend absolutely) go down to the rental agency to pick up the gear. The people who rent such equipment are generally reasonable and honorable people; while they will not intentionally send you out into the wilds with something that will not work, they make mistakes just as anyone else does. Also bear in mind that half of all the problems with rental gear can be traced to the user's unfamiliarity with it. Check out each and every piece of

The test engineer can help you tie your camera(s) into the event. With the help of this engineer, the plane took its own picture just after it left the launcher.

equipment, hook up all the cords and trippers and check them, all before you walk out the door of the agency. In the field, if you have a failure and can get to a phone, call the rental people and lay your problem where it belongs. Often the rental people can tell you what to do to put the equipment back into operation, or they can air-ship a substitute piece in time to save the assignment.

Hazardous Operations

In the photography of hazardous operations, the choice between a telephoto lens and a normal lens on a remotely operated camera may depend on the temperature and the time of day. On a hot day, the heat-waves rising from the earth may make long shots impossible except in the early morning, and your only alternative may be a protected camera close to the site. Radio-operated shutter releases will work at distances of from a few hundred feet to a quarter of a mile; or, with adequate batteries, you can lay a land line for a

hundred yards or so. Either method should be tested several times before the event.

Sometimes the electronic equipment that programs the sequence of events in the operation itself can be used to trip your cameras. The project engineer will be able to arrange that, if the test equipment is compatible with yours; it usually can be made to work.

Auto winders now available for many cameras make it possible to shoot more than one picture per event, and more elaborate motor drives for 35 mm cameras can help you to get either a series or the one picture in a situation that cannot be precisely timed.

MILITARY BASES

Military bases present certain special problems with which you should be familiar, since a large percentage of industrial field testing takes place under the watchful eye of Uncle Sam's Armed Forces. Nearly all test facilities are under fairly rigid security, even if the function that brings you there may not seem to call

This shot was made with a remotely tripped camera. The photographer was ordered by the Range Safety Officer to stay 200 feet away. Less than one second after this picture was made, the near booster failed and the sky was raining flame and metal parts. Photo, courtesy of the Northrop Corporation.

for it. You will need a "visit request" approved by the base security before you ever set foot on the base; your own company's security office can help you with that. You will be checked in and out of the base, and your movement while you are there is likely to be rigidly circumscribed. You will be permitted access only to the areas specifically approved on your visit request, and you may even be escorted by a representative of the base provost marshall's office to ensure that you do not stray. People who carry cameras are more than normally suspect; don't argue.

The range safety officer is another person with whom you should not argue. This officer has the final say in how any test on a military base is to be conducted. He or she will tell you where you can and cannot be to take your pictures, and where you will be at what time during the course of events leading up to and just following the actual test. The safety officer may get in your way, but he or she can keep you from getting killed. I did argue with one once, but he prevailed (they *always* do) and he was right. I got my pictures, and I

didn't get hurt, but I got the worst scare I'd had since I quit flying airplanes, and I stopped arguing with range safety officers.

THE FREELANCE ON LOCATION

The freelance learns early to cope with location problems; everything he or she does is on location. Some problems are unique to the freelance. Because he or she is an independent contractor, and not an employee of a company that is already cleared for access to a military base, access to the base may be more difficult to arrange, and an actual security clearance almost impossible to come by. Either or both can sometimes be arranged, but it is very difficult.

A local contact is even more important for the freelance than it is for the in-house photographer, because he or she is less likely to have other sources of information on the inside. Because the freelance's connection with the assignment is likely to have been arranged through an advertising agency or de-

Penny Wolin-Semple, a free-lance photographer on assignment in Wyoming, investigates the aftereffects of coal mining.

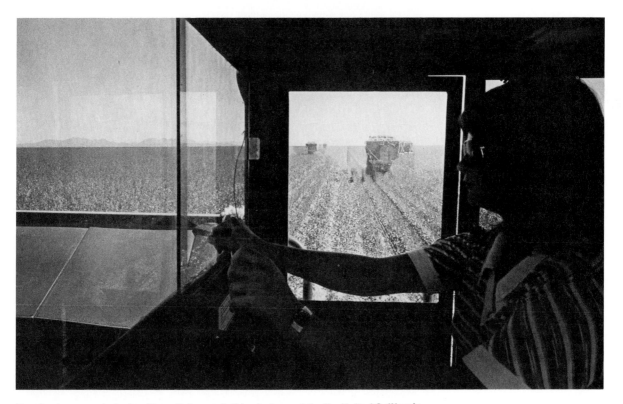

Farming is now an industry. Steve Kahn made this photograph for the United California Bank's annual report. Photo © Steve Kahn

The freelance must be prepared to operate anywhere in the world. This shot was made in Hong Kong for the Flying Tigers. Photo © Steve Kahn.

sign studio, the location contact may have to be reached through the agency, which calls its own contact within the company, who will in turn try to reach a person at the location. If there is an in-house photographic organization, and the freelance has not stepped on any toes there, that may be the shortest route to a location contact; it's worth a try. The in-house photographers will know their way around the company, and perhaps even around the location in question; they can be a goldmine of information for the freelance who has not offended them.

We have mentioned this before, and almost certainly will again: The photographer, in-house or freelance, *must* keep all appointments and meet all commitments. One of the most important functions of the contact/photographer relationship is the help it gives you in meeting schedules. Assembly lines, shipping departments, test operations—all func-

tion on schedules of their own. Few of them can be bothered with supporting a photographer who shows up at the wrong hour or on the wrong day—no matter whose fault it was, or how good the excuse. If an act of God prevents your getting to the appointed place at the appointed hour, call the affected people before that hour; you may be able to salvage the situation if you show, by calling, that you are making every effort to minimize the inconvenience to others involved.

SUMMARY

"Location" shooting is anything that takes you away from your home base, whether it's across town or out in the China Sea. All location assignments have certain things in common, chiefly the difficulties associated with being away from your back-up facilities. It pays to expect the worst in terms of accidents

84

TABLE 1-SUGGESTED LIGHTING, FILM, AND FILTERING COMBINATIONS FOR LARGE AREAS WITH MIXED LIGHT SOURCES.

If predominant light source is	and is contaminated with—	supplement with this lighting—	use this filter on the camera—	and this film in it.
Daylight	Fluorescent and/or Tungsten	Strobes, Blue Flash, or Quartz/Dichroic*	None	Daylight
Tungsten	Fluorescent and/or Daylight	Quartz 3200K	None	Type B
		or		
		Tungsten flash	81C	Type B
Fluorescent	Tungsten	Strobes, Blue Flash, or Quartz/Dichroic*	FLD**	Daylight
		None	FLB**	Type B
	Daylight	Strobes Blue Flash, or Quartz/Dichroic	FLD**	Daylight

*Dichroic filters on a 3200K light source convert it to 5400K, an approximation of daylight.
**FLB for Type B film and FLD for daylight are "averaged" filters, to be used when the fluorescent illumination is mixed or of an unknown type. When the specific fluorescent type is known, refer to Table 2, the chart on fluorescent filtering, for more precise filtering recommendations.

and equipment failures, and to be prepared to cope with them.

The paperwork routines associated with traveling for your company are likely to be inflexible, and coping with them requires that you know the procedure and start it as early as possible. Draw expense money that will be adequate to cover emergencies; you will have emergencies, and cash is a quick fix for a great many problems.

Your local contact is important to your peace of mind and to the execution of your assignment; make use of this person's knowledge and capabilities.

Off-site locations are much like your home base, with all the amenities, but without your normal back-up. Where such a location has a photographic department, professional courtesy works both ways, but it has to start with you; keep the peace and profit by it.

Your *big* lighting problems are likely to be those on location, and your tools for coping with them include portable quartz lights, electronic and incandescent flash, rented movie-lighting equipment, and choice of camera size, film types, and filters.

Field locations have most of the disadvantages of off-site locations, plus those of remoteness; you may be a long way from telephones, electrical outlets, and hamburger sandwiches. The same features of the assignment that require its being in the field may also require that you be remote from the immediate vicinity of the event and shoot it with long lenses, motor drives, or remote controls, or with all three.

Military bases involve a lot of extra paperwork, and your movement on such bases is likely to be limited to that required for the execution of your specific assignment, as approved by base security. You will be further limited in your choices of timing and location by the range safety officer, who will be busy keeping you from being killed.

Freelancers learn early to cope with location problems, because they are always on location. But they have special problems with military security and with local contacts. They—and all other industrial photographers—must remember to keep their appointments and meet their commitments.

TABLE 2—KODAK FILTERS FOR KODAK COLOR FILMS

See film instructions for current recommendations and corresponding speed values.

Light Source	KODAK Film			
	Daylight	Type A	Tungsten	Type L
	(KODACHROME, EKTACHROME, KODACOLOR, and VERICOLOR II Professional, Type S)	(KODACHROME 40, 5070, Type A)	(EKTACHROME)	(VERICOLOR II Professional, Type L)
Daylight	None*	No. 85	No. 85B	No. 85B
Electronic Flash	None†	No. 85	Not recommended‡	Not recommended
Blue Flashbulbs	None	No. 85	Not recommended‡	Not recommended
Clear Flashbulbs	No. 80C or 80D§	No. 81C	No. 81C	Not recommended
Photolamps (3400 K)	No. 80B	None	No. 81A	No. 81A
Tungsten (3200 K) Lamps	No. 80A	No. 82A	None	None

*With reversal color films, a KODAK Skylight Filter No. 1A can be used to reduce excessive bluishness of pictures made in open shade or on overcast days, or pictures of distant scenes, such as mountain and aerial views.

†If results are consistently bluish, use a CC05Y or CC10Y Filter with KODAK EKTACHROME and EKTACHROME Professional Films (Process E-6); use a No. 81B Filter with KODACHROME or KODACOLOR Films. Increase exposure ⅓ stop when a CC10Y or 81B filter is used.

‡KODAK EKTACHROME 160 or EKTACHROME 160 Professional Films (Tungsten) can be exposed with a No. 85B Filter.

§Use No. 80D Filter with zirconium-filled clear flashbulbs, such as AG-1 and M3.

STARTING FILTERS AND EXPOSURE INCREASES* FOR TEST SERIES WITH FLUORESCENT ILLUMINATION

KODAK Film Type	Type of Fluorescent Lamp†					
	Daylight	White	Warm White	Warm White Deluxe	Cool White	Cool White Deluxe
Daylight Type and Type S	40M+30Y +1 stop	20C+30M +1 stop	40C+40M +1⅓ stops	60C+30M +1⅔ stops	30M +⅔ stop	30C+20M +1 stop
Type B or Tungsten and Type L	85B‡+30M +10Y +1⅔ stops	40M+40Y +1 stop	30M+20Y +1 stop	10Y +⅓ stop	50M+60Y +1⅓ stops	10M+30Y +⅔ stop
Type A	85§+30M +10Y +1⅔ stops	40M+30Y +1 stop	30M+10Y +1 stop	No Filter None	50M+50Y +1⅓ stops	10M+20Y +⅔ stop

*Increase a meter-calculated exposure by the amount indicated in the table to compensate for light absorbed by the filters recommended. If this makes the exposure time longer than that for which the film is designed, refer to the table on page DS-36 for further filter and exposure-time adjustments that must be added to these lamp-quality corrections.

†When it is difficult or impossible to gain access to fluorescent lamps in order to identify the type, ask the maintenance department.

‡KODAK WRATTEN Filter No. 85B. §KODAK WRATTEN Filter No. 85.

This table is from Kodak publication E-77, *Kodak Color Films for Professional Use.* ⓒEASTMAN KODAK COMPANY, 1977

VII

The Studio

Your studio should be large enough to handle anything you will ever need to shoot in it, equipped to support not less than three setups at one time, and have enough different kinds of lights—including a controllable northlight window and balcony spots—to illuminate anything you will ever shoot. That is what it *should* be.

Unfortunately, that is not what it *will* be. Unless you are one of the very, *very* few who are privileged to lay out their studios before the building actually goes up, you will make do with whatever space you can negotiate for—which in all probability will not be entirely ideal.

SIZE AND DESIGN

Most interior spaces in industrial buildings do not convert naturally to good studios, and building space that is not in use a hundred percent of the time is anathema to efficiency experts and facilities engineers; you will have to fight for all you get. What you can do is think out just what your needs will be, and hope that with the facts at hand you can persuade the facilities people to give you something you can live with. My own first studio

was the photo office. I shot small setups on my desk, large ones I shot wherever they were; "location" meant anything I couldn't shoot on my desk. With any luck at all, you should do better.

BASIC REQUIREMENTS

The basic requirements for a studio come first.

- It *must* be clean, in an area you can keep free from dust.
- It must *not* be close to heavy equipment that will cause vibration in the shooting area.
- You *must* be able to exclude exterior light, even if it means painting over the windows.
- You *must* be able to cut off the ceiling fluorescents.

That last item is more important than it may at first appear. You may think that you can overpower the ambient fluorescent with your studio lights, and to the naked eye it will appear that you have done so, but your film knows otherwise. Contamination of electronic flash or quartz light with fluorescent will give fits to whoever does your color printing, and it will

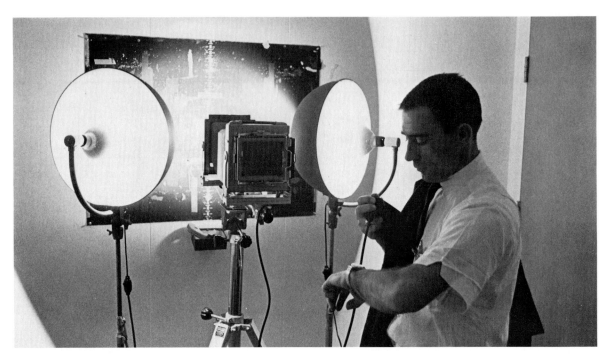

The best copy work in color requires the use of polarized lights. The units shown here can be converted to electronic flash for making quality 35 mm slides. Photographed by Robert Thornton of Northrop.

not make your engraver very happy, either. Earlier we discussed ways to cope with the problem of mixed light sources on location; you should understand that those are expedient measures for making the best of a bad situation and are not to be confused with what you do in a studio where you have full control over the lighting situation. If you cannot arrange to switch off those overhead fluorescents when you need to, get rid of them permanently.

Sizes of the objects you will be shooting should be considered. In some companies you will never need space greater than that needed to shoot the vice-president himself, or a handful of small parts on a table. In others, an area large enough to handle objects the

size of an office desk will be routinely required. Keep in mind the need for space to arrange the lights, room to back the camera off to a reasonable distance and still walk around it, and last but not least, a door that is big enough to admit those larger subjects. If it is necessary to allow other functions to overlap into your studio area, try to keep those functions compatible both in environment and in scheduling; otherwise, you may be forced to shut down one part of the operation in order to set up another.

A darkroom should be adjacent to the studio, because loading film and processing test exposures should not involve treks across the plant. This is one of the trade-offs. You may be offered an excellent space for a

studio in a more remote location, away from the labs, and its very remoteness is one of the things you will have to consider.

Ceiling height is a problem; unless you are certain your work will be limited to shooting small tabletop arrangements, ten feet should be the minimum height. You will sometimes want your lights to be as high as their stands will permit, but they get pretty hot during a long shooting and you need to keep a reasonable distance between the lampheads and the ceiling, particularly when there are fire detectors installed in the overhead.

Paint the studio white. Ceiling, walls, even the floor should never be any other color. When you need color, you can add it with filters, gelatins, or colored cardboards; but if your very walls are painted some bright hue, it is very hard to avoid some contamination in the lighting. The human eye is very forgiving, and will ignore the green tinge reflected onto a subject's face by an adjacent green wall, but the color film will forgive and forget nothing. In certain special circumstances, one black wall is sometimes useful, but normally you will be better off with all white.

EQUIPMENT AND FURNISHINGS

STUDIO LIGHTING EQUIPMENT

Lighting equipment, too, should be selected with an eye to the kind of work you expect to be doing. As we discussed earlier, you may have to compromise at first, with your portable location lighting units doubling as studio lighting. However, studio lighting problems call for some features that are not really compatible with portability, and if you will not be using the lights on location, you can do better work with lights designed just for the studio.

Even here, you have choices to make between incandescent lights and electronic flash (unless you can afford both). Again, the kind of work you will be doing is the key. Some subjects are sensitive to both light and heat, and are best shot with electronic flash. Subjects that may move slightly during the longer exposures required with tungsten also may be better photographed with electronic flash; and this doesn't necessarily mean just people. Plants, paper objects, and some plastic items are not so stable that a lens will not detect their movement during a long exposure.

For real control, there is no substitute for tungsten light. This is partly because you can see better what the light is doing, but also because of the optical and physical differences in the equipment. The smaller filaments of the incandescent lamps make them inherently more controllable than the electronic lamps are at this stage of their development.

Whatever your choice of lighting, you will want to start with a minimum of three lights— one spot and two floods. You can add the refinements as you get the budget to buy them.

Special types and sizes of lamps can be very helpful in handling the special lighting problems in the studio. Among them are

Inky-Dinks	Broads
Boom Lights	Umbrellas
Spots	Ringlights

The inky-dink is one of the most useful lights in the studio. The name is not a joke; it may once have been a trade name, but it has come to mean any tiny spotlight—100-200 watts—and it is surprisingly useful for putting a small amount of light exactly where it is needed.

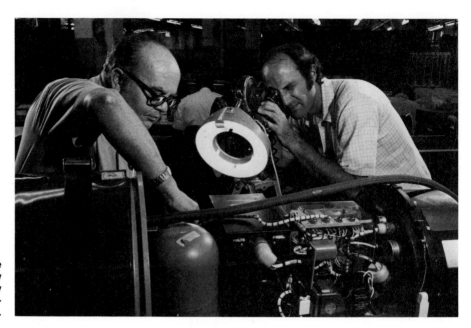

For close-in work where the subject must be fully illuminated, Tom Smalley of Northrop uses a ringlight. Photo by Gil Nunn.

The boom light, which came to us from the movie industry, is a spotlight that is supported on a counterbalanced boom which sits atop a regular vertical light stand. This makes it possible to hang a spot over some part of the set without its stand's showing in the picture. A common use is as a hairlight in portraiture, but it has many other uses.

Broads are large light sources, usually designed to bounce light onto the subject from a large integral reflector.

Umbrellas are the latest versions of the broad, and are very widely used now as main lights for portraits and groups; they are also useful wherever a large soft light is needed. Umbrellas are available in a wide variety of shapes, surfaces, and materials, and most of them can be used with either an incandescent source or electronic flash.

The ringlight is usually an electronic flash, although there is at least one fluorescent unit on the market. This is a light source in the shape of a ring that fits around the lens; you shoot through it, and the subject is thoroughly (and only) frontlighted, with a slight "dark halo" effect on the background. Industrial photographers have used it for years to shoot into complicated wiring or plumbing setups, and for that purpose it is excellent.

BACKGROUNDS

Backgrounds are important, usually for what they are not, rather than for what they are; we use them not so much for themselves as for what they hide. They make it possible to shoot pictures of equipment, consoles, and other products without the intrusion of wastebaskets, coffee cups, and windowframes into the picture. A background emphasizes the subject by eliminating distractions.

Seamless paper. The simplest way to arrive at an absolutely neutral background is to use the seamless roll paper sold for photographic purposes. It comes in rolls up to almost 13 feet wide by 100 feet long (4 m × 30.5 m), in a wide variety of colors, and usually in a matte finish, although some more exotic finishes are available. A roll 107 inches wide by 36 feet long (2.7 m × 11 m) costs about as much as a ten-sheet box of 4 × 5 inch Ektachrome. There are various sets of hardware on the market that make it possible to store several rolls of different colors on one wall, and roll each one down as it is needed. One such unit, called the Rollaway, offers a model that holds three rolls of 107-inch-wide paper and costs about $200; there are other units available from $50 up.

The point of the roll-paper background is that it is seamless; it covers the seam between wall and floor. On large sets in very large studios this seamless effect may be achieved by structurally coving the wall to the floor, and painting the wall, cove, and floor in one continuous color. Again, this is done only where the subject matter requires a large set, and the budget is correspondingly large; most industrial photographers never see such a set.

Flat. Ordinarily the industrial photographer does not get involved in the kind of portraiture that calls for special backgrounds; but if these are required, they can be bought or built in several different forms. One of these is the "flat," usually a frame about 8 feet (2.4 m) square covered with heavy cloth and painted with some unobtrusive pattern; sometimes it will even be painted to simulate a paneled wall.

Front projection is one other variation on the background theme that you should know about, although you may never run into

it in an industrial photographic studio. This consists of a projector with a very complicated (and expensive) optical system that projects a background past the subject on the axis of the camera lens. It is almost as tricky as it sounds, and it has its limitations, but it does work. Because of its cost (well into four figures) and its limited applications, it is seldom used in industry.

PODIUMS, PLATFORMS, AND LIGHT TABLES

Because it is neither convenient nor practical to photograph small objects on the floor, they must be brought up to a working height. Here, the photographer has several options. One is a sturdy plywood box, measuring 18 × 36 × 72 inches (46 × 92 × 184 cm), closed on all six sides. This is quite useful, but in a small studio it may be very much in the way when it is not actually in use. Another possibility is to rig a modified draftsman's table, with a sup-

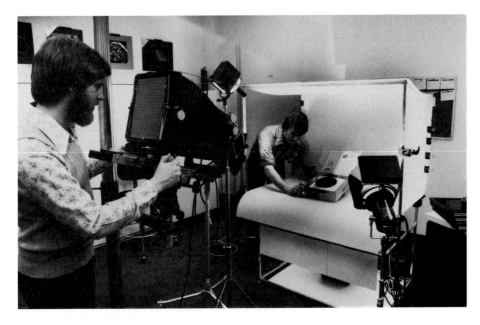

Jack Grossman and an assistant, John Beusse, set up a shot on a table that has a translucent top coved to create a modified "tent" effect. Photo by Jack Grossman of Lawson Products.

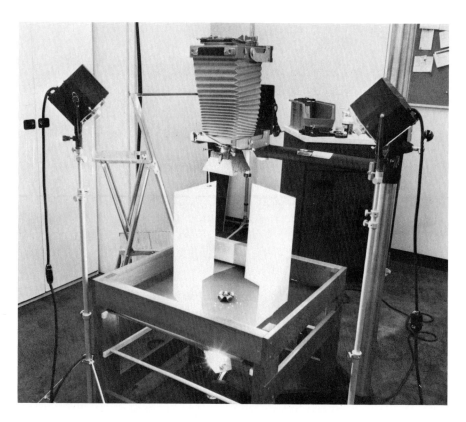

Above: This multilevel table can be used to create many special effects in
the studio. Note the light underneath. The picture being made in this setup
has been published several times. *Below*: Close-up of the shooting table,
showing how the multilevel glass parts slide into place. Both photos by Jack
Grossman of Lawson Products. (For the results, see color section.)

port for a 36-inch (92 cm) roll of paper at the back to provide it with its own seamless background. The top may be level or tilted slightly toward the front; it works very well. Similar units are available on the market, and at least one of them has a permanent translucent plastic top that curves up at the rear to make a background (see illustration). Used without a background light, the plastic looks like an ordinary opaque background; when necessary, it can be lighted from the rear to provide a completely shadowless background for small parts.

You can improvise variations on this sort of situation by using glass shelves for support, and lighting the backgrounds underneath and behind them to provide a great variety of effects. One option is a glass-topped table, with shelves below to support background objects or colored papers.

SHOOTING METHODS

REFLECTIVE OBJECTS

Objects that are themselves highly reflective, such as chromed items, polished gears, shiny tools, or silverware, are often best lit with "tents," which are overall coverings made of tissue paper, cloth, or even white cards. In this situation, you are photographing the reflection of the background, rather than the actual surface of the object being photographed.

A complete tent may give an overall gray effect, so it is often best to let a little direct light in somewhere to bounce directly off the shiny surface; this helps to show that the surface *is* shiny. Putting strips of black paper on the inside of the tent helps add contrast, but the strips must be very strategically placed; you need an assistant, and one of you tries the various locations for the black paper while the other watches the ground glass for the desired result. It is a trial-and-error process, but it is very effective.

Where the highly reflective object is only a part of the problem, and the rest of the set must be normally lighted, there are dulling sprays available that will dim the sheen without killing it entirely.

TRANSPARENT OBJECTS

Glass or transparent plastic items present almost the opposite problem. Here, instead of photographing the background's reflection in the shiny object, you photograph the distortion of the smooth lighting of the background by the object being photographed. Usually this calls for setting the subject up on a shelf—often of glass—where it can be physically separated from the background, and then varying the lights on the background until the desired effect is achieved. Again, it is sometimes best to let a little direct light strike the shiny surface of the subject; the specular reflections do much to define the character of the material of which the subject is made. Such objects are naturals for the use of colored lights, and interesting effects can be achieved with either colored gels over the lights or reflections from colored boards. If the subject is very simple in shape, that shape can sometimes be defined by the use of a striped or checked background; but if the object being photographed is at all complicated in shape, important detail may be lost to the complexity that such a background introduces. The results may also give the impression of being "gimmicky," so such techniques must be used with care.

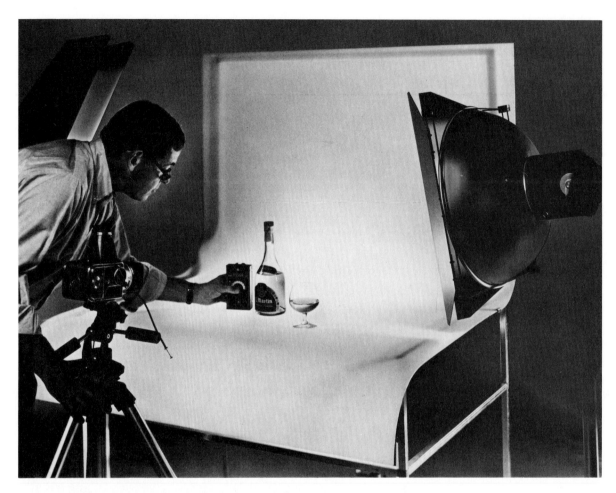

The coved plastic top of this table makes it easy to shoot small objects, and totally shadowless effects can be obtained by lighting from below. Photo, Bogen Photo Corporation.

In extreme cases there may be one critical edge of a transparent object that no amount of variation in the lighting will define. When this happens you can fall back on touching up that edge of the object with a grease pencil. Use it very sparingly, or its lack of delicacy will give you away. And never admit that you did it; some industrial photographers consider such tricks to be slightly unethical or unprofessional.

VERY SMALL OBJECTS

Very small objects can be photographed either on light tables, on sheets of glass in front of white backgrounds, or in special light boxes, made for the purpose, which are available on the market. Light boxes, which operate on the principle of lighting the subject(s) from all sides and from behind, work well enough for some small parts; but the very

principle indicates a lack of flexibility. For some small objects, light boxes do not work as well as the more primitive method of putting the parts on a paper background and experimenting with one light at a time until desired effect is attained.

GIMMICKS AND GADGETS

Just as in the darkroom you will eventually develop your own set of dodging tools and burning-in cards, so in the studio you will arrive at your own bag of tricks for coping with the problems that nobody ever told you about. To support small parts on a table you will need a box containing small blocks, clothespins, C-clamps, pieces of wire, chunks of rubber erasers, and maybe even a lump of modeling clay. For those impossible-to-reach spots in a tricky lighting setup you will have a small mirror that can be propped up out of sight to kick a bit of light in where you need it. If the job is being shot with electronic flash, you can sometimes hide a slaved portable unit back

Gil Nunn of Northrop is shown here making color slides for a marketing presentation. The marketing department of your company might well be a prime market for your services. Photo by Robert Thornton.

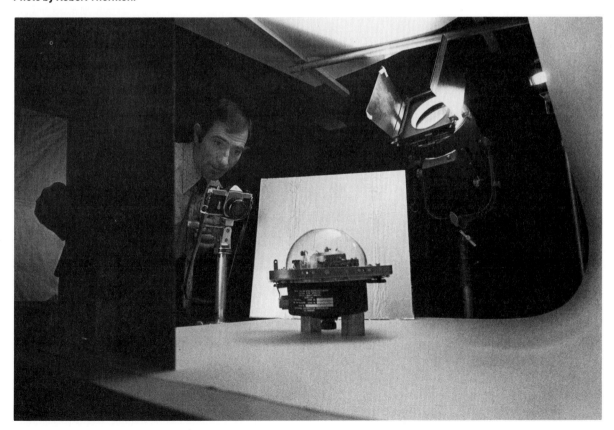

inside the setup, to be kicked off by the camera's flash. These tiny slaved portables can be a big help in keeping stray wires out of the set.

Exposure meters do the same thing in the studio that they do elsewhere, but there are variations available for special purposes. One of them has special grids which let you read the relative brightness of your incandescent lights without turning the lights on and off to read one at a time. There is a meter that slips into the back of a view camera, to take a through-the-lens reading. Still a third type of meter—and one which is quite remarkable—is the electronic flash meter. You set it for the kind of film you are using, put it in the set next to the subject, and fire the flash units. In the 1 / 1000 sec. or so that the strobe flash lasts the meter calibrates the light and gives you a reading in *f*-stops. Some of these meters cost less than conventional light meters, but they come in a wide variety of styles, some battery-operated and some AC, and the price range is also wide.

CAMERAS

CAMERAS FOR SMALL OBJECTS

The camera side of small-object photography gets more complicated as we approach the point where the image on the negative may be as large as the object being shot. With 35 mm cameras such closer work is best done with bellows attachments, the best of which make it possible to adjust focus by moving the back of the camera as well as the lens. Automatic extension tubes accomplish the same result, but do not give you the option of focusing with the back of the camera. With either bellows or extension tubes you can use a lens-reversing

adapter, which makes it possible to put the rear surface of the lens toward the object. Optical theory states that this will give a sharper image; while the theory is, of course, correct, whether in practice the image improvement is worth the effort has been questioned.

If you do a lot of work in this area, you will want to consider the purchase of a macro lens, which is a lens that has been designed, both optically and in the mount, to do superior work at close ranges. Most of them are furnished in mounts that permit focusing down to the 1:1 range, and some can be used with either the bellows or extension tubes to go well beyond that.

With all three of the above options, one main problem is the difficulty of positioning your lights after the camera has been moved so close to the subject. Recently the manufacturers have helped resolve that difficulty by developing longer-focus macro lenses, which combine the larger image with a greater lens-to-subject distance. These are true macro lenses, most in the 100–105 mm range, and are not to be confused with the so-called macro-zooms, which are just closer-focusing zoom lenses. When even the longer lens will not let you position conventional lights properly, it is sometimes possible to use the ring-light.

THE VIEW CAMERA

One assumption we made at the beginning of this book was that its readers are likely to be familiar with hand cameras and basic dark-room procedure; but that assumption did not embrace the view camera, because many schools do not mention it at all and there are many otherwise-well-trained photographers who are making a living without ever having set one up. In some fields of photography you

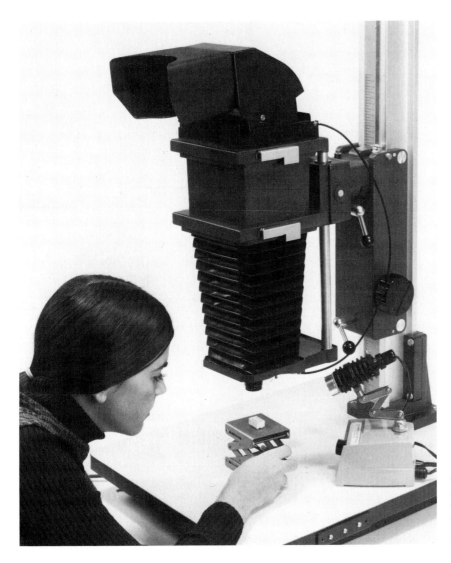

When you have a lot of small objects to photograph, macro capability is helpful. Here, a special camera is used. Photograph, courtesy of the Polaroid Corporation.

might never require the flexibility of the view camera, and that may be true even for some industrial photographers. If you hope to consider yourself a fully qualified industrial photographer, however, you will need to be at least familiar with the basics of view-camera work. In most industrial photographic departments this is at least a minimum requirement; and in some departments the view camera is the backbone of the operation. For this reason, we will cover view-camera work—very lightly—right here. This review will not make you a view-camera expert, but it should help

you reach the point where you can set up a view camera and start learning how to use it.

The design of the view camera permits independent movement of the lens and the back to achieve control of focus and apparent perspective. Both the front and the back of the camera, independently of each other, can be raised, lowered, shifted to right or left, tilted forward or back, and swung to the right or the left. These movements control the shape and focus of the image, which appears upside-down on the ground glass and the same size it will be on the negative. A tripod

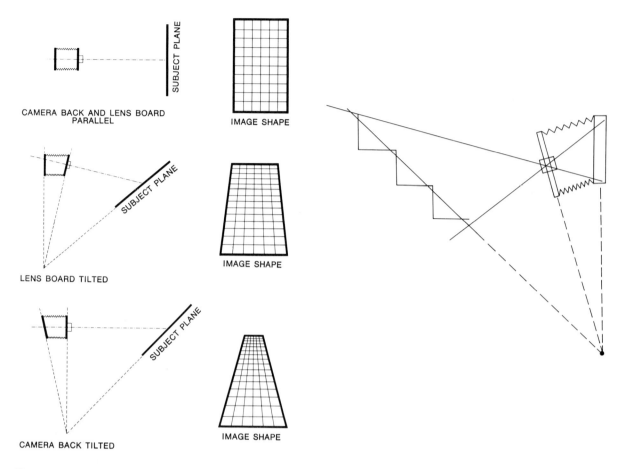

View cameras can be manipulated to change the look of the subject.

for the view camera is not optional, but necessary; the view camera cannot be hand held. Nearly all view cameras today use either 4 × 5 inch or 8 × 10 inch sheet film.

The basic optical principles are relatively uncomplicated, and understanding them puts you in a position to control the camera. To summarize:

- you control *distortion* with the *back* of the camera;
- you control the *plane of focus* with the *front* of the camera.

Memorize that, understand it, and remember to use it; it is the basic principle of view-camera operation.

A typical studio situation. Maybe you have to photograph a rectangular piece of electronic equipment on a white background,

with accessory cables and adapters arranged in front of the box. For handbook work, military specifications require that a photograph of such a unit be made with the vertical lines parallel, and be shot from slightly above the top surface of the box. The camera, shooting from this angle, will normally allow the vertical lines in the image to diverge at the top, making the box look smaller at the bottom; this is the image any reflex camera would give you. To correct this image with the view camera, you tip the back of the camera until it is precisely parallel to the vertical lines in the subject; this will straighten the verticals in the image. If the lens standard were also parallel to the back, the plane of focus would be parallel to the front of the box, and the cables on the table in front of it would be out of focus. Tip-

98

In order to photograph the meson accelerator at the Los Alamos Scientific Laboratory from this angle without distortion, a view camera was necessary. Photo by Ivan Worthington, staff photographer.

ping the lens forward will tilt the plane of focus away from the top of the camera, in the same direction as (and to a greater degree than) the tilt of the lens. This will lay the plane of focus generally through the more important parts of the subject, and stopping down the lens will bring the rest of it into focus.

You will learn that it is necessary always to focus as accurately as you can first with the controls on the front of the camera, because the longer lenses used on view cameras have such a shallow depth of field that stopping down is not as effective with them as it is with the shorter focal lengths. The view camera is a great teacher of discipline for the photographer.

Shooting architectural exteriors. In these situations, the same necessity for keeping the vertical lines parallel will still require that the *back* of the camera be parallel to the verticals in the structure; you will probably have to adjust the rising front to eliminate foreground and take in the top of the building; and you will again adjust the *front* of the camera for the best plane of focus. But suppose you *want* the lines in the image to converge at the top, to make the building look taller?

Set the camera up on the tripod with all the controls at neutral, and tip back the whole camera to take in the entire building. Just as you can neutralize the feeling of perspective by straightening out the verticals, you can ex-

aggerate the feeling by tipping the back of the camera even farther away from the vertical. In the horizontal plane, you can do the same thing to a wall. Swinging the back *parallel to the wall* will tend to minimize the wall's apparent length, and swinging the back farther *away from the parallel* will tend to exaggerate it. In either case, of course, it will be necessary to control the plane of focus with the front of the camera. *Any adjustment you make at the back of the camera always requires a compensating adjustment at the front.*

View camera refinements. The manufacturers of view cameras have begun catching up with the needs of photographers, and some cameras now have indexes and scales on their standards and bases that make it easier to relate the movements of the front and back of the camera to each other, and to the base. These scales are of different kinds and utilize different principles in their controls, and you will need to study them very carefully to find one with which you can be most comfortable. Whether the front and the back tilt from their centers or from the bottom may not be important, but photographers tend to feel strongly about it; they just don't agree on which way is best.

Some models even offer such exotic refinements as reflex focusing and electronic shutters. There are also variations in the actual flexibility and amount of control available in the basic camera. It is possible to buy features you do not need and cannot use, and to spend a lot of money doing it. As in all other equipment purchases, you should select a view camera with your actual needs in mind.

Photographing small objects. Because of its flexibility and control, the view camera is sometimes used in the studio to photograph very small objects. This usually means a long bellows extension, which may lead to problems with vibration. Cable releases help; an old-fashioned bulb with an air-operated shutter tripper is even better. In the absence of either, it is sometimes best to set up for a time exposure, draw the slide, hold the slide in front of (but not touching) the lens, trip the shutter, and wait for the camera to settle down; then take the slide away for the required exposure interval, put it back in front of the lens, and close the shutter. This avoids the shutter vibration problem, but there are others. In extreme cases, a particularly long bellows will actually vibrate to sounds in the building; not visibly, but enough to flaw the image. The cures for that problem are silence and electronic flash.

TRIPODS

As 35 mm and 120 reflex cameras became more versatile, a lot of photographers walked away from our tripods with a sense of relief, glad that it was no longer necessary to carry *those* things around. Later we came back, having learned that the smaller the camera, the better the image has to be, and that one way of assuring sharper images was to use the tripod at least part of the time. Some people can hand-hold a 35 mm camera at 1/30 sec.; a great many more only *think* they can. Smaller cameras can do a lot of things that the big ones can't; and some of those things call for exposures a lot longer than 1/30 sec.

A tripod should be
strong enough to support your camera safely;
as portable as your needs dictate;
rigid enough to prevent vibration;
flexible enough to put your camera where you need it to be.

Sometimes there's just no place to put a tripod. A bystander with a camera caught the author pondering this problem. A solution exists now—turn to the next page.

Depending on your needs, you may also want
 a center post that cranks up and down;
 reversible feet, with rubber tips for indoors and steel points for outside;
 a reversible center post, for hanging the camera very low;
 side arms, for hanging the camera low, but right side up.
A tripod need *not* be strong enough to sit on, no matter what the magazine ads tell you; if it is that strong, you are paying too much and carrying too much weight. If it will never be used outside the studio, your tripod's weight is not a major factor; but if you will be carrying it as one more piece of gear out in the field, every ounce counts. A center post that cranks the camera into position is a very useful refinement, especially in tight spots. A reversible center post lets you hang your camera low to the ground, but upside down; with a side arm you can have the camera just as low, but right side up. Pay attention to the joints where the legs attach to the top of the tripod, and to the fittings that let you vary the lengths of the legs; these are the trouble spots in most tripods.

Steel tripods are strong, durable, and heavy; aluminum ones are much lighter and the good ones are quite adequate for most use.

The tripod head makes it possible to tilt the camera up or down and to level it without bothering to get the tripod itself exactly level— a considerable convenience. Heads are also the source of many of the difficulties photographers have with tripods. The best heads are the ones that are the most compact and have the largest bearing surfaces for locking down into position. This is especially true of the joint between the base of the head and the top of the tripod, where head/tripod problems are most likely to arise.

SUMMARY

Studios should be large, have high ceilings, be next to your darkrooms, and be fully equipped; usually, you will settle for something less than that. Some things you should not compromise on: The studio must be clean, it must not be subject to vibration, you must be able to shut out the daylight, and you must be able to cut off the ceiling fluorescents.

For that no-place-to-put-a-tripod situation, Photoline of Aberdeen, South Dakota, has developed "The Other Hand," a device that can support cameras as large as the 4 × 5.

Your shooting area should be large enough to handle what you will be required to shoot in it, but there is no great benefit to be derived from its being any larger than that. The ceiling should be no lower than ten feet. The walls and ceiling should be painted white; they *must* be white if you expect to shoot color film there.

Lighting equipment also necessarily involves compromises. If you have the budget to buy lights specifically for the studio, you get your greatest flexibility and control from tungsten; but electronic flash has its points, especially if you have to photograph anything that moves or is sensitive to light and heat. Special sizes and types of lights, including inky-dinks, ringlights, and umbrellas, can be very useful.

Backgrounds are important because they help emphasize the subject by eliminating distractions behind it. Roll-paper backgrounds are relatively cheap, flexible, and easy to install and use.

Podiums, glass shelves, and small tables all have their usefulness in solving certain studio problems. Shiny objects can be tented, or sprayed to a duller finish when photographed in combination with other materials. Transparent materials can be shot either against plain lighted backgrounds or, in the case of very simple shapes, against stripes that help define their outlines.

Small objects can be photographed on glass or in specially designed light boxes.

You will develop your own kit of studio gimmicks, gadgets, and tricks; it will probably

George Meinzinger, a photographer in Los Angeles, created this illustration for the 1973 annual report of Craig, Inc., manufacturer of a wide variety of electronics products.

include mirrors, clips, clothespins, clamps, blocks, and modeling clay.

Exposure meters are available that either are designed specifically for studio use or can be adapted to it; they include those that read one light at a time, those that read from the ground glass through the lens, and those that measure electronic flash or stroboscopic lights.

Roll-film cameras can be adapted for close-up work with bellows attachments, extension tubes, or macro lenses.

View cameras are not needed in all phases of photography, but most industrial photographers need to know how to use them. All the controls of a view camera are designed to exploit the basic principle that the back of the camera controls distortion and the front of it controls the plane of focus; all uses of the camera spring from that principle. Doing close-up work with the view camera brings up special problems that require special answers.

Tripods are not obsolete, even for small cameras. The tripod you use should be selected with your particular purposes and needs in mind, and it should be no larger or heavier than you need. Special tripods are available to meet almost any special requirement.

VIII

Executive Portraiture

Like the term *industrial photography*, executive portraiture covers a lot of ground. For the purposes of this chapter we will consider the executive to be someone on the vice-president / general-manager / chairman-of-the-board level. You will be called upon to photograph lower echelon people who may be called managers, executive officers, directors, group chiefs, and a lot of other things; but the problems and constraints are different, and in any case the tone for these portraits is set at the higher levels.

STYLES AND TRENDS

These exist in executive portraiture just as they do in wedding and fashion photography, with the important difference that in the case of the executive portrait, the changes are less the photographer's doing. Fifty years ago some chief executives flatly refused to be photographed at all, and those who were photographed wanted to be portrayed as Captains of Industry, Defenders of the Faith, and Builders of Empires. They were photographed to look like the barons they considered themselves to be.

The day of the robber baron and laissez-faire economics may or may not be entirely a thing of the past, but the day of boasting about it is. Corporations large and small are today well aware of the value of good public relations and the goodwill of the community, and they want their chief executives to be seen as fellow human beings. So these individuals are often shown in more relaxed poses, in less formal atmospheres, and sometimes even smiling. This is not the rule in every company, but it is the trend. I have recently seen a series of portraits of chief executives of each of several divisions of a major corporation, with each man standing in front of ''his'' operation. All were smiling and relaxed, and several wore the appropriate headgear for their locations, including hard hats. All of this appeared in that holiest of corporate documents, the Annual Report. These were not snapshots of these people in the field, but executive portraits, and they were very good indeed; because they gave the viewer more than just a person, they included the environment that was integral with the company image.

THE USE OF THE PORTRAIT

Where the portrait is to appear will sometimes impose limitations on the treatment of the subject. A photograph to accompany a public

Illustration of a trend: These two "working executive" portraits of the same middle-management executive were made several years apart. For the first shot, by Robert Thornton (above), the executive wore a coat; for the later one, made by Gary Wehr, he was comfortable posing in his shirt-sleeves. Photos by courtesy of Northrop.

For news releases, a simple head shot can be cropped as a vertical for one-column reproduction. Extremely sharp focus is always necessary in industrial work, especially for reproduction on newsprint. Photo by Robert Thornton of Northrop.

relations announcement of the executive's appointment to the board of a university will ordinarily be a head shot, because that is what is needed for a one-column cut in a newspaper. A photograph planned to accompany a feature story in a trade publication might show the executive at work in an office, or observing in the field some aspect of the operations discussed in the story. Whether you can show an executive in shirtsleeves will depend on the company, the individual subject, and the use to which the picture will be put. Opportunities to photograph the top executive will not come every day, and while you

are making an official portrait for the annual report you should try to back it up with variations that you can use for other purposes.

ARRANGEMENTS

The appointment for a portrait sitting will probably be your responsibility. The requirement will come from the public relations department, more than likely, but P.R. will usually leave it to you to set up the actual shooting. If it is to be a head shot for local news release, you may want the subject to come to the studio; more often you will be ex-

Originally shot in color for a specific application, this portrait is typical of the inside/outside lighting-balance problems you can meet in glass-walled executive offices. Here, interior illumination was boosted to equal the outside light. Photo by Robert Thornton, Northrop.

privy to many of the most private thoughts of the company and of the boss, filtering incoming calls and visitors and determining who will take up the executive's time and who will be politely rejected. The secretary is actually the executive's representative in dozens of situations each day, and must be absolutely dependable. The secretary to a top executive is therefore likely to be one of the more capable and competent people in the company; the boss is not entrusting the conduct of the office to some cutie whose assets are all obvious from across the room.

So if you want to be treated with the respect due you as a professional, begin by treating the secretary with the respect due to *that* status. This is not likely to be a problem; the boss *needs* to have his or her picture made, and you and the secretary will work together to set this up. I make a point of this because you will need to be in the executive's office for a while before the sitting, and arranging the time so that this is possible is something only the secretary can do for you. The secretary can also juggle the amount of time spared for the sitting; and if you have established the necessary rapport ahead of time, enough time may have been set aside for you to do the job properly.

EQUIPMENT

The equipment needed will vary with the assignment, and this is one reason you will need access to the executive's office ahead of time. Major executives often have offices with large windows, which can complicate a portrait sitting; you will need to make up your mind as to how to handle them. Drapes may be the answer, or you may want to put dichroics on your quartz lamps and use the daylight as part of your lighting. If your assignment in-

pected, by the nature of the requirement placed on you by P.R., to make the picture in the executive's office. To do this you will need the help and cooperation of the executive's secretary.

This is important. If your exposure to the cartoons in men's magazines has led you to think of secretaries exclusively in terms of females with large bustlines and sexy smiles, permit me to disabuse you of that notion right now. An executive's secretary is necessarily

Robert Thornton photographed this executive with electronic flash bounced from an umbrella reflector. This permitted a more active sitting and eliminated the need for retouching. Photo of this chief executive, by courtesy of Northrop Corporation.

cludes color, you will want to cut off overhead fluorescents if at all possible. If you can arrange to drag in your studio electronic flash, so much the better; the shorter exposure times of flash lighting make it easier to shoot the more relaxed kind of portrait favored today.

The umbrella reflector for lights can be especially useful for its soft light and broad coverage. The trend toward the more casual kind of portrait is also a trend away from the inevitable retouching that went with the old-style portrait; umbrellas make unretouched images more acceptable. There are still exceptions to this unretouched look; your P.R.

people will advise you.

If the secretary has arranged for you to have the office far enough ahead of the sitting, you may have the opportunity to try various lighting arrangements on a stand-in, or even a chance to shoot and process some test exposures, if you're lucky. You will not get many chances to shoot the top executive, and you can't afford to blow even one of them.

DEALING WITH THE EXECUTIVE

The executive is the person at the top. He or she was probably once an expert in one of the technologies the company deals with, but is

108

now an expert *manager.* The executive hires the best people available to handle the work, and manages the people, not the work.

The value of an executive's time may be measured in dollars per minute, and this time is not wasted on details that are supposed to be left to others—of which you are one. The executive is not a photographer. I was fortunate in having this rather forcefully pointed out to me very early in my career, and I have never forgotten it. I was photographing a general manager who had a reputation for being particularly demanding of his subordinates, and I had not had much earlier contact with him. I was pussyfooting around, trying to get my pictures without actually giving him orders, when he finally lost patience with me. "Dammit," he blew up at me, "*you're my expert.* You tell me what you want me to do." This did not make me feel any less intimidated just then, but I did get my act together, get my pictures, and get out—which was what he wanted me to do.

Do not waste the executive's time asking for preferences. The top person wants to do whatever the expert (that's you) says to do in order to get the picture made. That is, to get the sitting over in the most expeditious manner possible, and get back to work. Tell the executive what to do and how to do it, and you'll both be happier.

In the process of telling your subjects what to do, and photographing them when they do it, you will have opportunities for conversation. Chief executives do not encourage familiarity; but they are human, and they will talk with you if it develops you have anything to say, or if you appear to have interests congruent with their own. On the face of it, this would not appear to be likely; you do move in different circles. But even chief executives have children, cars, homes, and hobbies, and they will talk about them in a congenial atmosphere. The general manager who explained to me my position in the company turned out to be an avid amateur photographer; as a matter of fact, a very good one. It gave us something to talk about on later occasions. A pleasant conversation will relax you both, and help you to get better pictures.

What you *do not* want to do is ask questions about things that do not concern you, make impertinent comments about the executive's job or secretary, or—worst of all—try to take advantage of having the executive's ear to promote yourself.

THE FREELANCE

The freelance who is making a portrait of the chief executive will probably be given a little more latitude in choice of times, style of photograph, and backgrounds than the in-house photographer, just because of the outside-consultant / visiting-expert syndrome. Even more than the in-house photographer, the freelance is the authority, and even the public relations people may defer to his or her judgement on all the details of the portrait.

The inside contact for the freelance may be the P.R. director, but it is more likely to be the executive's secretary who actually sets up an appointment for the sitting. And here, even more than in other contacts with the organization, the photographer must make every effort to be on or ahead of time for all commitments. Chief executives are most unforgiving of people who waste their time, and their secretaries *never* forgive. Most of all this is true if the shooting is scheduled to take place out on location, because complicated arrangements with other people may be involved.

The freelance is at a disadvantage in one area: not knowing the company and its cus-

tomers the way an in-house photographer does. This can lead to the violation of some tabus. Every business has them, and it may be worth a few minutes of your time to discuss any such pitfalls with the public relations people before you start out on the assignment.

In some companies, an executive is never photographed in shirtsleeves or other-wise informally dressed; in others, no matter how informal the situation, no evidence of cigarettes must show. The executive may actually have a bar in the office, but it is not likely you could show it. If the portrait is in color and is planned for use in a proposal to one of the Arab countries, you must not allow the color blue to intrude at any point; blue is the Israeli color. In the face of today's environmental

Today, executives are often photographed in this easy, relaxed style, even for publication. Photograph by Bill Jack Rodgers, Los Alamos Scientific Laboratory, NM.

Executives were once photographed like this, and the negatives were retouched before proofing. See opposite page, page 105, and the color section for other contemporary looks. Photo, by courtesy of the Northrop Corporation.

consciousness, you should not allow active smokestacks to show in the background. It is easy to make errors if you don't know the company and its customers. Ask a few questions.

SUMMARY

Styles in executive portraiture change, just as they do in fashion photography, and the trend in the last few years has been away from the formal toward the more casual.

Both the style and the format of the portrait may depend in part on the use to which it is to be put, and you should know what that use is before you go to the sitting.

Executives' secretaries tend to be highly capable people, and to wield influence greater than their titles would lead you to expect. Your rapport with the secretary—or lack of it—will be a factor in your getting a good portrait of the boss.

Select the equipment for the assignment after seeing where you will shoot and what kind of a picture is needed. Electronic flash, especially when used with umbrellas, is very useful for the kind of portraits most often shot today.

111

Executives are people at the top who hire experts in the middle to do the company's work at the bottom. You are one of those experts; don't waste the person's time by asking for decisions about your work. Say what you want and expect that the executive will be glad to do it and get the sitting over with. Establishing a comfortable rapport with the executive is not impossible if you take the time to learn what his or her interests are, and if you avoid the appearance of familiarity. The freelance can be a little more informal because of not being permanently in the chain of command.

The freelance benefits from the outside consultant/visiting expert syndrome, and suffers the disadvantage of not knowing the company as well as employees do. It pays the independent to take time to learn enough about the company to stay out of trouble.

This stunning picture of a phosphoric acid complex in Florida was used
for a W.R.Grace & Co. report cover. Photography by John T. Hill, a freelance.

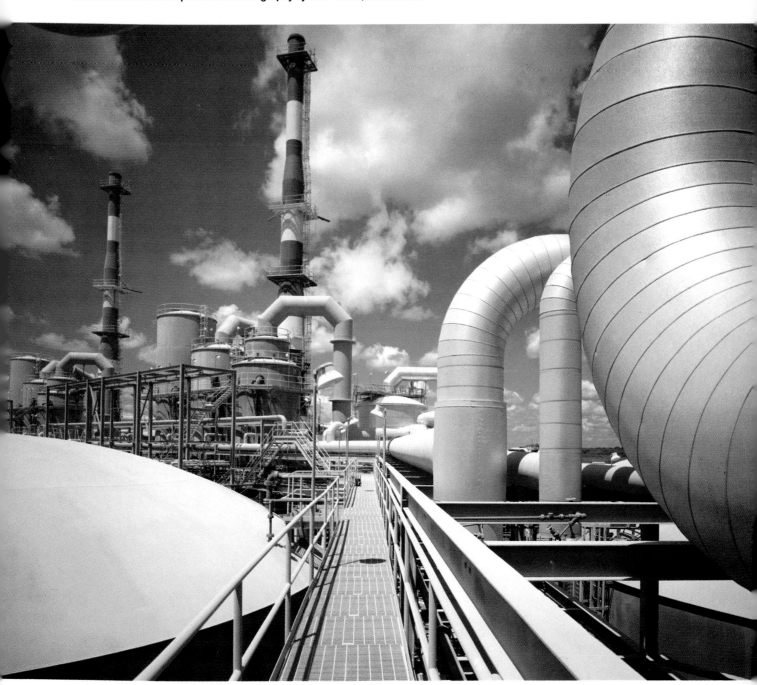

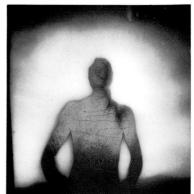

Right: These four images, made for his own interest by George Meinzinger of Los Angeles, persuaded prospective clients of his creativity. They won him such assignments as that shown on the opposite page, and others illustrated elsewhere in this book. *Below:* Typical of the new informal approach in executive portraiture is this photograph of the top executives of Ashland Oil by Harry Seawell, a veteran freelance.

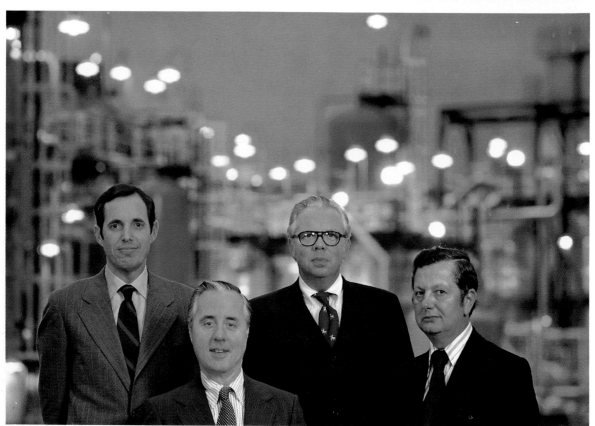

An example of new thinking in executive portraiture is this unique treatment by George Meinzinger for Shareholders Capital Corporation's 1970 report.

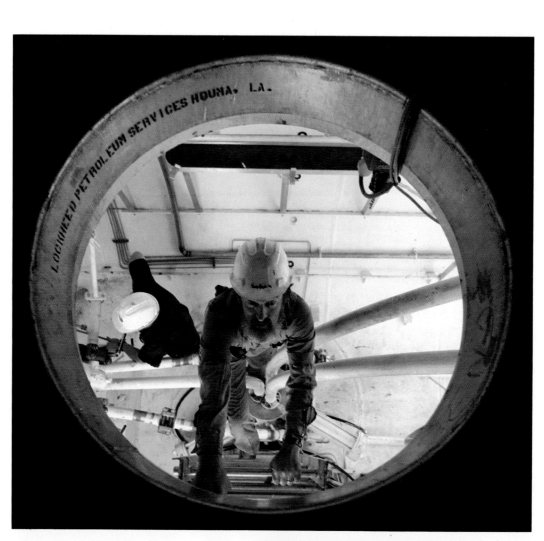

Above: This may look like a casual "grab" shot, but it was very carefully composed and lighted by George Meinzinger for Lockheed. *Right:* Clothing—even a space outfit—has to be tried on. Vic Luke photographed the event for Northrop.

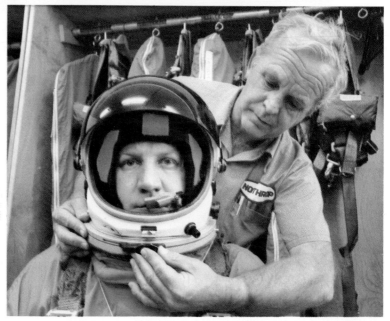

This image by Chuck Hrichak, Bethlehem Steel staff photographer, works as both design and illustration because of the strong center of interest and three-dimensional effect.

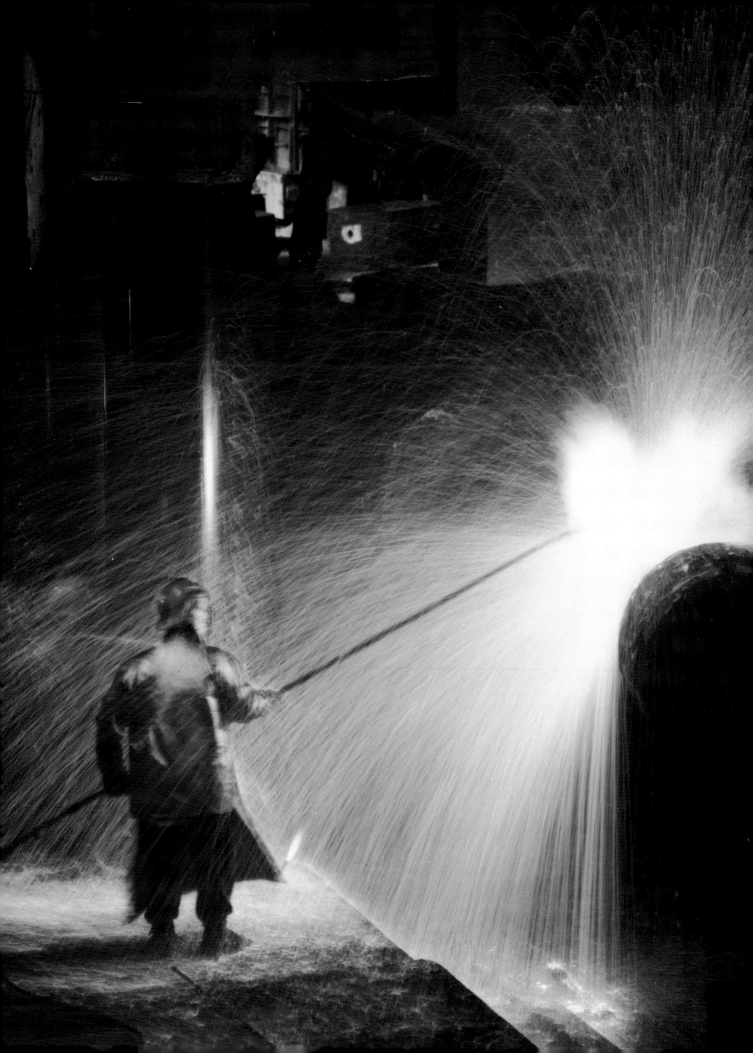

Workers are important "industrial" subjects. *Left:* Nikki L. Martin, image analyst, studies satellite photographs for NASA. Photographed by George Meinzinger for Lockheed's 1976 annual report. *Below:* Fire-fighters test the latest in clothing and equipment in use against the real thing. Photographed for Northrop by Vic Luke, staff photographer.

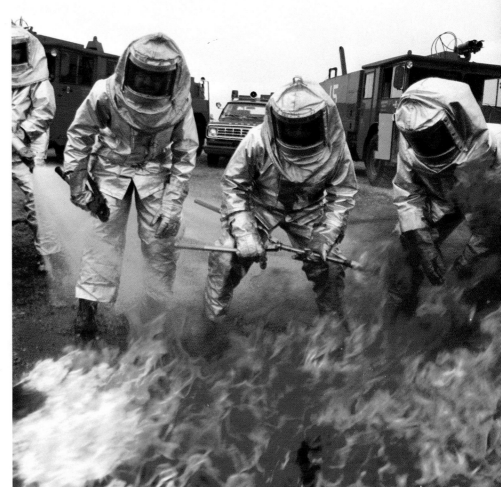

Opposite page: Self-illuminated events can inspire the thinking photographer. Peter Treiber, staff photographer, used an exposure of several seconds for this dramatic shot of a steel worker. Photograph, by courtesy of Bethlehem Steel.

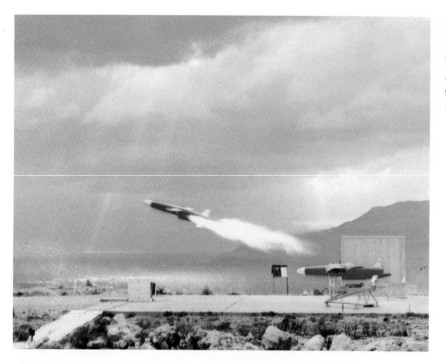

Opposite page: **The design elements tell the story: man, steel, sky. Henry Fagliano, Photographic Director of Bethlehem Steel, swears the temperature was 126 degrees F when he shot this transmission tower in the Mojave Desert.**

Industrial photography is full of variety, from hats to jets, from sea to sky.
Above: **An aerial target launched on a misty morning in the Mediterranean was photographed by Robert Thornton of Northrop.** *Below:* **These hats were shot by John T. Hill for annual report of W.R.Grace & Co., international chemical company.**

One picture can say it all, yet making that picture a good picture can tax the photographer's imagination. Photo by courtesy of the Ashland Oil Corporation.

This creative solution to the problem of photographic story-telling was arrived at by George Meinzinger for a Lear Siegler annual report to the stockholders.

Mastery of awkward lighting situations is vital to the success of the industrial photographer. A tire warehouse is no thing of beauty, but Tom Engler of Los Angeles handled this one so well it added interest to Petrolane's annual report.

Left: Aerials have their own problems, but the photographer seems to have beaten them in this shot for Ashland Oil. *Below:* John T. Hill was on freelance assignment in Alabama for W.R.Grace & Co. The nearly backlit shooting angle he chose emphasizes the rounded shape of the structures.

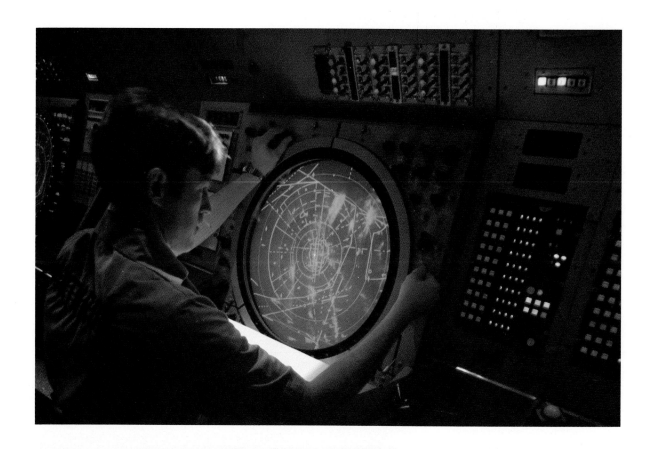

People add interest to industrial illustration. *Above:* Vic Luke, a Northrop staff photographer, used the radar installation's own illumination to light this shot. *Left:* Some of the fascination of scientific research was caught in this close-up by Robert Thornton, also for the Northrop Corporation.

The human figure gives reality to this haunting vision of a glowing cave—
coal mining, as seen by Len Ross, staff photographer for Bethlehem Steel.

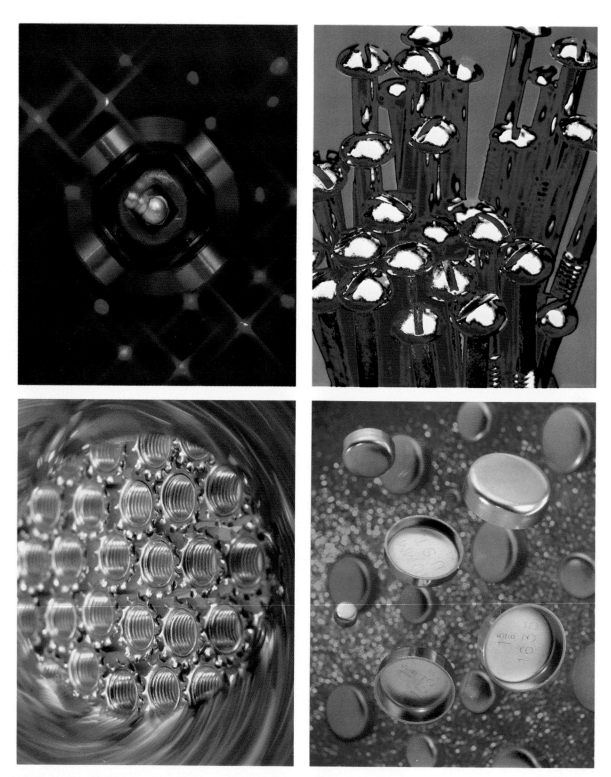

Making small parts look glamorous is the forte of Jack Grossman of
Lawson Products. His techniques are explained in Chapter VII; but tech-
nique means little without the vital ingredient: the photographer's eye.

IX

Public Relations

Like nearly everything else that the industrial photographer gets involved in, public relations work falls into several different areas, all of which tend to overlap at times. And, as always, the in-house photographer is expected to be, if not expert, at least competent, in each category. The range of such assignments can be dismaying. You may very well find yourself photographing janitors in the morning and foreign heads of state at a formal dinner in the evening; it happens in this business.

INTERNAL PUBLIC RELATIONS

Internal public relations is the work that helps the company keep its employees informed and their morale high; at least, that is the idea, and to a surprising degree it is effective. Almost everybody likes to have his picture taken, and having a lot of people-pictures in the company paper is certainly one of the best ways to assure its being read; besides having the news about the breadwinner's working-place, the in-house publication may have pictures of the employee, too—in which case, he or she is likely to take home a *dozen* copies. The Public Relations Director, or Company Information Officer, or whatever this official is

called in your company, knows all this better than anyone else and will be one of your best customers. Getting the paper read and carried home is one of the things this person gets paid for.

That is a break for you. There will be peaks and valleys in your normal work load, and in a free-enterprise economy it is always dangerous to run out of work in any department of a profit-making organization. No matter that you were on overtime last week, and that things will undoubtedly pick up again later in the month; having people wandering around with nothing to do makes managers nervous. One of your jobs as a photographer will be that of digging up work that can be done when you are not otherwise busy, filling in the valleys of the schedule and keeping your boss from getting nervous about the manloading. One of the best sources of such assignments is your company newspaper. The public relations director will sometimes be glad to throw an assignment your way just to help out; more often, it is better if you can scout up the story yourself, then sell it to the director.

Your job takes you all over the plant, sometimes to places the P.R. people may never see, and that gives you an advantage

Above: When a popular long-time employee of a company retires, photographs of the event may make the community newspaper, will appear in the in-house publication, and certainly will be put into a book of prints for the individual. This shot by Gil Nunn of the Northrop Corporation. *Below:* A scheduling problem caused this jam-up on the assembly line, and alert photographer Gary Wehr of Northrop quickly took advantage of the situation. The picture ran in several newspapers and the house publication.

you can exploit. Keep your eyes open for employees who make unusual contributions to the company's operations, or have been on that particular job longer than anyone else in the history of the company, or invented the job in the first place. Learn which of them have unusual hobbies, or make special contributions to the community in volunteer or political organizations. Some people merely eat and sleep and go to work and watch television, but for others their jobs are almost interruptions in their otherwise very busy lives. Those very busy lives are full of opportunities for you to develop stories for the company newspaper. These stories, of course, become shooting assignments for the industrial photographer, because company newspaper stories about employees almost invariably require photographs.

OUTSIDE THE PLANT

COMMUNITY NEWSPAPERS

The smallest local weeklies and even the largest metropolitan dailies also contribute to your P.R. work load. In this day of more or less enlightened capitalism, the big companies are very sensitive to public opinion and extremely conscious of their community responsibilities, and your public relations director will be grateful for anything you can contribute for release to the media. Just what can and cannot be released is something of which the P.R. officer must be the judge, and you must spend some time learning what he or she wants and can use. Company policy is not always highly visible in these areas, and P.R. is much more attuned to its complexities than you are likely to be. You and the P.R. director have everything to gain and nothing to lose by working very closely together, and it is best to accept his or her evaluation of a particular story or photograph; in the long run, the P.R. person is more likely to be right. That is part of the P.R. job; your job is photography.

VANITY PUBLIC RELATIONS

Vanity P.R. is what we call the pictures we shoot to satisfy the subject's desire for publicity without any requirement—or even possi-

A woman takes over as manager of a department that had always been run by men, and a photograph illustrating the story will hit both the local newspaper and the company's in-house paper. Photo by Robert Thornton for the Northrop Corporation.

115

When visiting dignitaries are important enough to have the General Manager take them on a tour, photographs are almost always required, even though political or security considerations may prevent their being published. Photo by Robert Thornton of Northrop.

bility—for publication. Since the prints you will eventually deliver are themsleves the end product, and not meant for reproduction, some of the constraints of good P.R. pictures do not apply. Such pictures include the ones you make of a project director and crew on the day of the completion of the project, or at some important milestone in its progress. So also are those that are destined to hang on the wall in some vice-president's office. It's still public relations work, so far as the photographer is concerned, but the pictures do not have to communicate in the same way that regular P.R. work must.

The ultimate in vanity P.R. is the social affair hosted by a major officer of the company. Since such affairs typically include corporation presidents, politicians, and sometimes even a prince or two, the pictures can be important to the health of your career. For such assignments you are expected to be well-dressed, effectively invisible, and infallible. Good luck.

TRADE PUBLICATIONS

Specialized journals and magazines make an excellent market for your best industrial shots. There are literally hundreds of magazines that cater to very specific markets, and are very thoroughly read within those markets. As an industrial photographer, you will probably see two or three magazines each month that are planned and written especially for your part of the business; this is true for the people in every industry, craft, or profession. Electronics, data processing, facilities

This kind of photograph can make either a trade publication or an annual report. Photo by Robert Thornton for the Northrop Corporation.

management, plastics development, and procurement all not only have magazines directed to their particular needs, but also magazines directed to small specific areas within those categories. Many such magazines use a lot of inside color, and many more of them use color covers. All of them are on the lookout for good, punchy photographs that have news value to their readers. Unfortunately, you are not likely to have much opportunity to develop this market directly. Contact with the trades must be through the P.R. officer, whose job it is to "sell" the picture or story. Your best chance to hit this market will

come from shooting pictures of new developments, processes, or even buildings with the magazine cover possibility always in mind, and from seeing that the P.R. office is aware of every new happening in the company.

GETTING A STORY

The engineers and scientists who are the most likely to come up with newsworthy developments may not realize their photographic possibilities, and the P.R. department may be unaware of both the development and the pictures. Your job is to be the catalyst, to being the elements together and wait for the

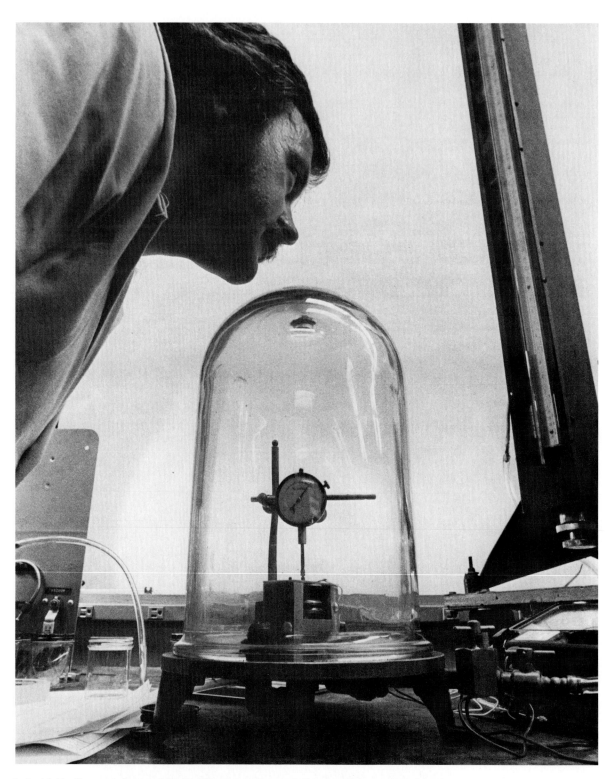

Industrial testing operations tend to be difficult to photograph. Careful choice of angle, background, and lighting brought order to this one by Robert Thornton. Photo, courtesy of Northrop.

reaction. Unless there are policy reasons for keeping the news out of the media, you will get all kinds of cooperation.

It sometimes happens that a story with great pictorial possibilities gets squelched because someone is afraid of releasing information that might be of help to the competition. You may be able to get around this by suggesting a photograph that will tell nothing the company wants unsaid, and yet be a publishable picture. If that doesn't work, drop it. Again, you are a photographer and communication is your business; for P.R. directors, *not* communicating is sometimes the most important—and most frustrating—part of the job, and they do not need some photographer's misguided enthusiasm to make the problem any worse than it is already.

Security

The problem of security—especially military security—always comes up when we speak of things we are not permitted to photograph. Certain things cannot be photographed for release because something about them carries the classification of "secret" or "confidential" or some other term. In this area, engineers or scientists working on the project should know the guidelines exactly—but often they don't. That is, they know the rules that apply to *their* work, but they may not know how those guidelines apply to *your* work, and the differences can get you into trouble. The rules that govern military security can be absolutely insane, and they sometimes are; but

they are the law, and they are enforceable. Don't take any chances in this area. If there is any question in your mind about the rules that cover what you are photographing, check with the company's security officer. The final responsibility for making certain a picture does not violate security regulations lies with the P.R. officer, who will submit it to the proper military office for review in doubtful cases; but there is no point in your expending a lot of time and energy in digging up a story and making the pictures if Security is going to kill the whole thing anyway.

Sometimes a new product is photogenic and newsworthy but the company is nervous about releasing too much detail. Here, Robert Thornton of the Northrop Corporation has made a publishable photograph of a subject for which normal treatment might have been too revealing.

119

This shot of a computer-controlled machining process would be suitable for either a trade publication or the house organ. Photo by Bill Jack Rodgers of the Los Alamos Scientific Laboratory.

EQUIPMENT

Your equipment plays an important part in your P.R. work, and your choice of camera will often be dictated by the assignment. Despite the use of high-quality 35 mm transparencies for covers on many publications, most of the magazines you will be trying to hit as an industrial photographer will prefer to see size 120 or 4 x 5 transparencies for covers. This is true, to a lesser extent, even for inside illustrations; but for the covers you need the bigger formats. Ordinarily, the things you will be doing for the trades can conveniently be shot on the larger formats, and they should be.

For black-and-white public relations work of all kinds the roll-film cameras have taken over, with the emphasis heavily in favor of the 35 mm. The advantages of size and weight are more important than ever when you must move quickly and deal with people who are not used to being in front of the camera—which is most of the time. Being able to shoot with ambient light can be a great help when you are photographing people who may be distracted or even made nervous by flash. Often you will do your best P.R. shooting when you can be as unobtrusive as possible and your subjects can almost forget you are there.

Even when flash is indicated, it can be less distracting to the people in the scene if you can avoid light stands and extension cords and instead use slaved portable electronic flash lamps held in position by an assistant or a volunteer; people are almost always willing to hold lights. The slaved flash

units can be very small and, with today's films, very effective. Properly used, they provide all the advantages of high speed, portability, and lighting control without the disadvantages of the old, head-on flash picture.

BUSINESS PRACTICES

Those business practices related to public relations are mostly matters of ethics, courtesy, and common sense. When your assignment calls for you to contact Mr. X and photograph him at his desk, you will call his secretary and make an appointment at least 24 hours ahead of time, if your deadline permits it. If it is necessary to speak with him directly, you will still go through his secretary to do it.

The model release problem comes up only when your photographs will later be used by the company in promotion of its products, and when there are recognizable people in the picture who are not employees of the company. It is best to avoid this problem entirely by not including in the picture anyone who is not on the payroll. Failing this, someone will have to obtain the appropriate releases.

THE DEADLINE

If anything is truly sacred in public relations work, it is The Deadline. The greatest picture you ever made is useless if it is delivered too late for publication in the paper, magazine, or whatever market it was promised to. If the P.R. director has confidence in you, you will be given all the time possible. Don't agree to deadlines you are not sure you can make; and once you have agreed to one, keep it even if it means loss of sleep, unpaid overtime, or going without a bath. If you have to call the manager of the XYZ project to tell him that the pictures he wanted this morning will not be ready until after lunch, he will probably forgive you; the P.R. director will not. *Never* miss a deadline.

ROLE OF THE FREELANCE

The freelance who is hired to do P.R. work has certain important advantages over the company person who might have been given the same assignment. When an outside photographer is brought in, that person was ob-

A visiting V.I.P. is always newsworthy. In the unlikely event that the public relations director does not order the pictures, you shoot them anyway. To be useful, prints of news events should be delivered quickly. Photo by Robert Thornton for Northrop.

viously selected and hired by Someone on High. This aura of official approval goes a long way toward smoothing the path of the photographer, and full cooperation is almost automatic. The "visiting expert" syndrome is also at work, and the freelance may find the job easier to accomplish and final approval more likely because of it.

None of this is meant to suggest that the freelance can safely ignore the normal courtesies in dealing with people, or that the realities of the deadline can be ignored. The freelance is an independent businessperson, and is expected to be businesslike, even if he or she *is* The Expert.

SUMMARY

Public relations photography required from the industrial photographer covers almost the entire spectrum of P.R. work, and the in-house photographer is expected to be reasonably competent in all of it.

Internal Public Relations is the bread-and-butter of P.R. work in industry, and is concerned with the activities of both the company and its employees. The company will use its in-house paper to communicate with its employees; but it is the interesting stories about the employees themselves—with pic-

Photographs of company employees at work are grist for the mill of the company house organ. This shot of Northrop Corporation's cinematographer Tom Smalley was made by Robert Thornton.

There are several different trade publications that might pick up a picture on the development of a new structural material for aircraft. Photo by Robert Thornton of Northrop.

tures—that will get the readership necessary to make the paper effective.

Nobody knows this better than the public relations director, who will therefore be one of your best customers. You will work together in the best interests of you both, and you are in a position to help each other.

Community newspapers, even the largest, are among your markets; and your P.R. people will be on the lookout for anything that can be released to them. What the P.R. officer *does not* want to release may be important; it is part of the job to know what should and should not go out. Don't argue.

Vanity P.R. will be a part of your job, but without the limitations and rules that apply to the pictures that must qualify for reproduction in the media.

Trade publications offer you your best chance to get a cover, and your best opportunity to dig up stories that your P.R. director might otherwise miss.

Both proprietary information and military security have to be protected, and either may

When photographer Gary Wehr became a father, he passed out cigars to the *women* in the department, and the picture by Robert Thornton made the company newspaper. Photo, courtesy of Northrop.

kill an otherwise successful assignment.

Your equipment must be highly portable, effective, and as unobtrusive as possible. For a lot of P.R. work, this means using a 35 mm camera and, occasionally, the small portable electronic flash units.

Public relations business practices are based on ethics, courtesy, and common sense. You can avoid upsetting an executive's business day by calling ahead and making appointments; always go through the secretary.

Releases are sometimes called for in P.R. work if any of the people in the pictures are not employees of the company. Such releases are properly the responsibility of the P.R. director, but you may have to help.

Respect for The Deadline is the holiest of rules in public relations; be prepared to meet your deadlines at whatever cost or go into some other line of work.

The freelance is the Visiting Expert brought in by Higher Authority and can therefore expect levels of cooperation not always offered the company photographer. Nevertheless, the normal courtesies are required, and The Deadline is just as sacred.

X

The Annual Report

One of the tastiest plums ever to fall into the lap of the industrial photographer is the annual report. Originally only a legal document that the Securities and Exchange Commission required be filed each year by the companies, it has come to be a major vehicle for corporate communications. Some of the best graphic design efforts in industry go into the creation of these carefully planned and expensively printed booklets. Fortunately for the industrial photographer, both company and freelance, the photography used in these reports is also imaginative and of top quality. There are still some companies whose annual reports are limited to a dull and dry recital of the year's profits and losses, but most of them are willing to spend a little money putting their best feet forward.

THE ANNUAL REPORT IN-HOUSE

Some annual reports are designed and produced entirely within the companies they represent, but most of them are sent to outside organizations at least for the design work, sometimes for the writing, and almost always for the printing. Even when the design is given to an outside house, the company photogra-

pher may be considered for the photography *if* he or she is equal to it. When this opportunity arises, you as the company photographer may find yourself competing with the best of freelances for the first time, and you are not likely to be given the assignment before you have proved your technical and creative abilities to the people who are in charge of producing the report.

ADVANCE PLANNING

If there is an annual report in process now, and you are not shooting it, right now is the time to start laying the groundwork for next year's assignment. As Horatio Alger-ish as it sounds, the one way to do this is to deliver, day in and out, better work than is required of you. Give every assignment you get the best you have to offer, and see that people know you are doing it. Submit your work to magazines, try to get it hung in local exhibits and art shows, get your better efforts out where they can be seen; and they will be remembered. Show what you can do in the way of creative work, work not done on assignment or even related to your daily jobs. As you can see from the illustrations, some top freelance photog-

Annual reports are carefully designed, expensively printed, and use the best photography the reporting companies can afford. They represent both a good market and good exposure for the freelance.

raphers set for themselves assignments that are simply exercises in creative thinking; they use the fruits of those assignments to show that they *can* think—and they get the top jobs that way. Technical excellence is not to be ignored, but it is taken for granted, and the real search is for creative thinking.

Look at annual reports, all the current and recent ones you can find, to see what kind of work is being done. Review those you can find for several years back, in order to identify the trends. This does not mean that you should copy the latest style of work you can find, but it may keep you from re-inventing the wheel, photographically speaking.

You have one tremendous edge on the outside photographer, and that is your familiarity with the company and its products. Take advantage of your position to make interesting and creative photographs of the company's facilities, products, and people, whenever the opportunity presents itself.

Study the work of experts. There are new photographers coming to the top every year, and there are new styles in photography developing all the time. Keep abreast of what's happening by reading the photographic and art magazines and annuals, and by attending art and photography exhibitions whenever they are available. Learn who in

your company has the responsibility for assigning the annual report, and find ways to let that person know that you want the work and that you can do it. You may be rewarded with a small trial assignment, to supplement the work of the freelance who drew the main report job. Don't knock it; give it your best, and prove that you are capable of taking on the whole job next year. Do not forget the matter of deadlines; the engineer whose prints are delivered a day late may in time forgive you, but the photographer who delays an annual report is in the doghouse forever.

You may even be assigned to go along with the freelance photographers and help them shoot the annual reports that you think

Annual report photography sometimes borders on editorial work, or illustration, as witness this shot for United California Bank's annual report. Photo © Steve Kahn.

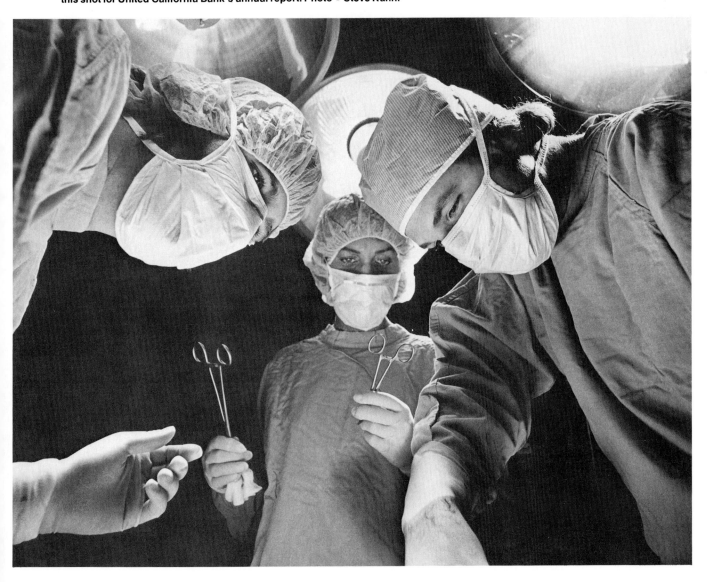

A man reading meters in a carpet mill becomes an interesting subject in the hands of a creative photographer. Photo by George Meinzinger for Patrick Carpets.

you should have had. Don't sulk. They got the jobs because they know something you don't, or someone thinks they do. Be a nice guy, help them do the jobs, and learn everything you can from them. Use what you learn to take the jobs away from them next year.

ANNUAL REPORTS FOR THE FREELANCE

For the freelance, annual reports offer an opportunity to participate in the highest level of industrial photography, with a chance for extensive travel while earning excellent fees. Depending on the client, you may negotiate payment at a job rate or a day rate, with all expenses paid. In 1980 the minimum day rate was about $450, going up to about $1750, with most experienced freelancers quoting around $1000 to $1200 per day. That sounds better than it actually is, of course; freelancers do not work jobs like that every day. Their assignments are likely to come in lumps, with one day here, ten days there, and a lot of dry days in between. Still, annual reports are good work, and they draw a lot of the country's best talent.

As a freelance, you turn up this kind of work in the same way the in-house photographer does, by bringing yourself to the attention of the people who make the decisions. Often this means the designer in one of the small design studios, and some freelances regularly make the rounds of such studios, keeping their work and their names fresh in the designers' memories. Having the best of your work published where designers and corporate ad managers can see it also helps, and so does having it exhibited in galleries

To lift this architectural shot out of the "routine" category, the photographer chose a time of day when the low sun would add dimension and mood to the information conveyed. The photograph (© Steve Kahn) appeared in the 1977 annual report of the United California Bank.

The fuzzy foreground here was a design element specified by the designer of the annual report for which Lou Jacobs, Jr., was making the picture. The machine seems even bigger in contrast to the size of the person operating it.

and art museums. Advertising agencies are sometimes involved also, even when they turn the actual design of the annual report over to a design studio; having your work and your name known to the art directors and account executives will not hurt your chances of being selected to do the report.

Sometimes the corporation's ad manager picks the photographer. One manager who handles the advertising for a multinational corporation, tells me he sometimes finds his best photographers by talking to those who call or write in commenting on a particular ad series and asking for a chance to work on it. He thinks such photographers are showing an interest in top-grade work, rather than a particular job, and he is impressed by

it. Of course, this man is a very sharp customer, and he can tell by your work whether you are more interested in his ad campaign or in the corporation's money. If he likes what he sees, he will then sometimes give the photographer an assignment or two, which could lead to an annual report job.

PREPARATION

Once you have been selected for the job, it is likely you will be taken into the plant by someone, possibly the designer, to have a look at what you will be shooting. If the organization has a photographic unit of its own, you will probably go there with the designer to see what photographs have already been made, either with an eye to incorporating them into

the book or as jumping-off places for your own work. In either case, you will be meeting the company photographer. A smart company photographer will cooperate with you, even if only to learn how to take the job away from you the next time, and you will need this person's help to do your job. The regular employee is the one who can tell you what time the shift ends on the assembly line, where the washroom is, and who to see to get the overhead lights turned on or off; the one who can provide spare extension cords, batteries, sync cords, bulbs, and film; and the one who can lend you a background you had no idea you were going to need. You need this person's cooperation. He or she will probably have been instructed to give you all aid and assistance, but while you are on the company photographer's turf, you are at that person's mercy. It will pay you to stay on good terms.

TRAVEL

Travel is almost always involved in annual report work, sometimes international travel. You will therefore need to obtain a passport and keep it up to date; after you get the assignment is no time to start dealing with the State Department. Some companies will arrange your reservations, get your tickets, and see to your hotel accommodations; others will leave you on your own, and let you bill them later for your expenses. Either way works, but which one you use should be clearly understood when you start the job.

NEGOTIATING FEES AND RIGHTS

This is probably as good a time as any to say that most of the problems between freelance photographers and their clients arise out of the failure of one or the other to be clearly understood. Nowhere is this more evident than in the areas of payment and residual rights.

Corporate public relations and advertising people are accustomed to dealing with outside photographers mostly in advertising, where the photographer usually turns over all rights to the photograph, and where, not coincidentally, he or she is likely to be paid a much higher fee *per picture* than is the case with the annual report. These people find it difficult, if

A freelance assignment for Lou Jacobs, Jr., was to show the huge amount of data generated by the client. This photograph was his response to the challenge.

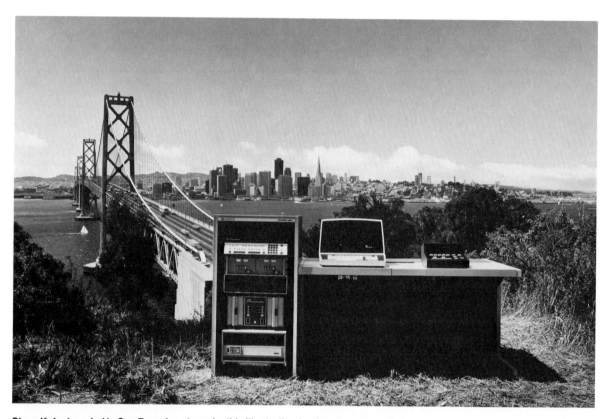

Steve Kahn traveled to San Francisco to make this illustration for the annual report of Computer Automation, Inc. Details of such freelance assignments are worked out well in advance. Photo © Steve Kahn

not impossible, to accept the idea that a photographer could be paid to shoot and deliver photographs for an annual report and expect to be paid again if the company decides to use the picture for other purposes at a later date.

Photographers, on the other hand, do not think it is reasonable for a company to pay for annual report pictures, then later expect to use those same photographs in national advertising without paying an additional fee. The new copyright law, which became effective in 1978, has reinforced the photographer's position (see Chapter XI).

The only protection you have against misunderstandings in this area is a full discussion of fees and rights before the shooting starts. Some freelances recommend putting a resumé of the agreement reached regarding fees and rights into a memo of understanding, and mailing a copy of it to the client. Rights granted and stipulations about the return of negatives and slides should be included on your invoice, but don't wait until then to spell them out because you may discover after the job is done that you and the client didn't really understand each other at all. What rights you will try to retain may depend on many things,

To illustrate the acrobatic capabilities of a new fighter plane, George Meinzinger of Los Angeles made this symbolic photograph in his studio, using a small model of the plane. Pictures from the series were used inside and on the cover of Northrop's annual report.

including how strongly the client feels about the matter and how badly you need the work; but what is really important to both of you is a full understanding of the ground rules before the game is played.

A short review of what rights are yours to sell or retain will be covered in the next chapter.

SUMMARY

Much of the best photography produced in or for industry is in the corporate annual report, and the in-house photographer must compete with the top freelances for the work.

With a little planning and a lot of creative effort, the company photographer can sometimes get his or her share of the annual report work. Technical excellence is a must, but the selection of a photographer for the annual report is made on the basis of creativity, and it is the job of the in-house photographers to bring their own creative efforts to the attention of the right people.

For the freelance, annual reports can mean interesting assignments, international travel, and an excellent return for effort expended. Contacts and assignments are made in the same way as the company photographer's, except that your contacts are likely to be concentrated in design studios and adver-

133

tising agencies. Some company ad managers are involved in selecting photographers and, again, are likely to make a choice on the basis of creativity shown.

The freelance working in a plant that has its own photographer must make every effort to work with the company employee, who can give you help you can get nowhere else.

The interests of the client and the photographer are not the same when it comes to the photographer's residual rights to the photographs, and it is important that an understanding on this matter be reached early in the game. A memo of understanding before the shooting and a complete invoice afterward can be used to spell out the rights of both parties.

The term "industrial" covers a lot of ground, both figuratively and literally. This cottonfield operation was photographed by Steve Kahn for the United California Bank's annual report.

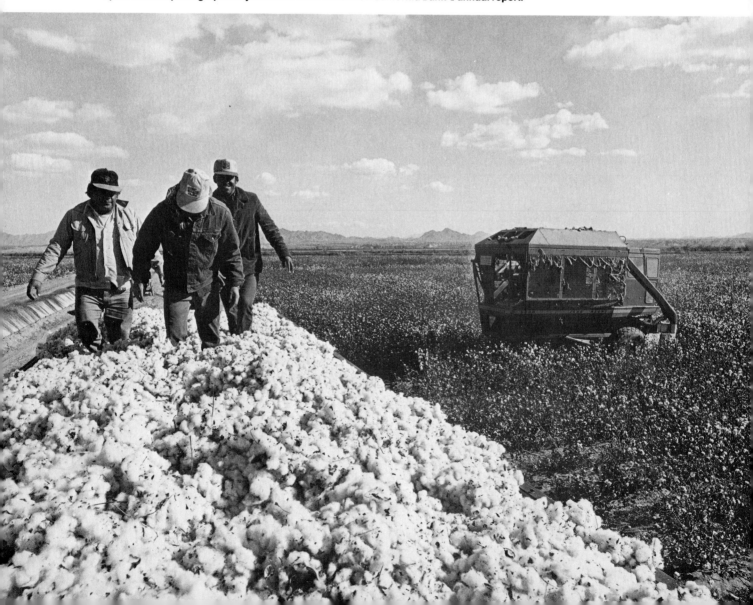

XI

Business

Photography may or may not be an art, a craft, or a science, but certainly it is a business. The in-house photographer who learns this very early in the game will find that a businesslike attitude toward the job will be observed and appreciated by the management, while a sloppy attitude toward the business aspects of the job will interfere with his or her career. The rewards and penalties for the way the freelance conducts the business of photography are even more certain: The rewards are even greater, and the penalties are swifter and more devastating. One photographic illustrator I knew, who went bankrupt twice before he learned the business aspects of his work, ultimately became extremely successful, both financially and professionally; he had finally learned to control his business. This was not because he made a choice between art and money—his work continued to be as good as ever—but he had learned how to make money doing it.

THE IN-HOUSE PHOTOGRAPHER/EXECUTIVE

The best advice I ever got on the subject of in-house photographic operation came from a tough, hard-headed old ex-admiral who first hired me to run a photo unit. "You're in charge of this department," he told me. "Run it *as if it were your own business.*" The important part of that statement is the recognition that the photo unit is a business within a business, and that it is expected to show a profit. In practice, that expectation often must be modified to accept the special circumstances surrounding the operation. Sometimes the benefits of having photographic services internally provided and controlled outweigh the benefits of any possible profit. But the photographer who manages an in-house unit, whether a one-person operation or one with 20 employees, without regard for costs, will sooner or later lose out to some cost-cutting efficiency expert. The company will then send the work to an outside photographer who is operating at a profit. In-house photographic units are expensive, highly visible, and a favorite target for cost-reduction drives. Running the operation the way you would if you had to live on its profits offers you the best chance to survive the periodic cutbacks that are almost inevitable in industry.

KEEPING RECORDS

Good records are the key to control of any business operation. You must know what your costs really are and where your money is

JOB NO.	REQUESTOR	JOB DESCRIPTION	PROJECT ACCOUNT	ITEM TASK	CH
L52	Boynton	PMT3	7987	0101	
L53	Nunn	Color Shots + Prints (BQM)	7962	1301	
L54	Wehr	Portrait	9301	0100	3000
L55	Smalley	B+W Prints from MP Film	9642	1601	
L56	Moran	Photo Search - Facilities	9301	0100	2830
L57	Miller	LN of Certificate	7924	0101	
L58	Mertz	Mil Spec Negs (185)	9301	0100	4200
L59	Pakula	PMT5 of Cartoons	9301	0100	1000
L60	Ralph	Color Negs + Prints of Rendevme	9601	1301	
L61	Calder	HT Negs - Photos Furnished	9301	0100	4200
L62					
L62					

The central log keeps you in touch with the work going on from day to day.

going; you also must know where your efforts are being spent, and whether they are effective. You may be morally certain that you are making color prints in your lab cheaper than you could buy them on the outside, but if you cannot prove it with convincing figures, based on accurate and complete records, nobody in management is going to approve your request for additional color lab equipment. For while you are "running" the business, the expenditure of funds for major purchases will probably have to be approved by at least two levels of management above you; and the people at those two levels did not get there by taking *any*body's unsupported word for *any*thing—you have to have the figures.

PAPERWORK

The right paperwork is that which gives you all the data you need, and *absolutely nothing*

more. It is possible to waste a great deal of time and energy keeping records and data for which you will have little or no use at all. You will soon learn which items to keep track of and which can be ignored. I once inherited a department which had been expending a considerable effort in maintaining seven different sets of forms, none of which would tell you whether a job that came in last Tuesday had been completed. After an analysis of the requirements, I was able to cut the seven forms to two, with no loss of real data and a substantial improvement in the accuracy and usefulness of the records.

Quantity of data is not the same as *quality* of data; get all you need, but don't waste your efforts keeping records you cannot use. At the same time, don't overlook anything you will need. Above all, don't allow yourself to collect any data you cannot be sure are correct. The only thing worse than no record is

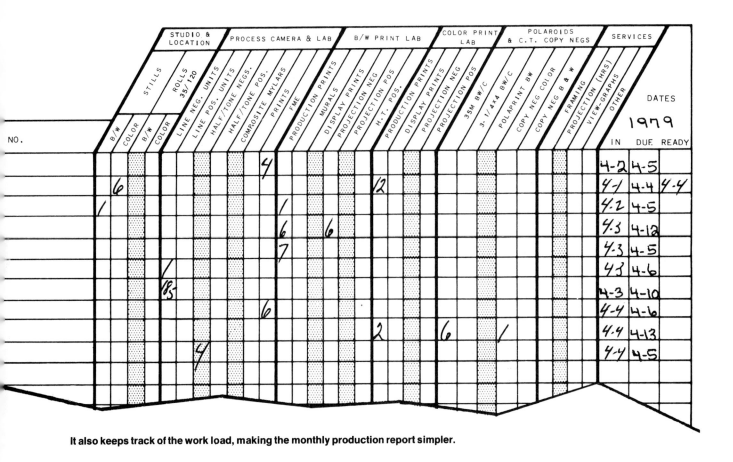

It also keeps track of the work load, making the monthly production report simpler.

an incorrect one. One of the best executives I ever met once told me: "It ain't the things you don't know that get you in trouble; it's the things you know for sure *that ain't so!*" Don't do any guessing: Keep records, and be sure they are as accurate as you can make them.

THE CENTRAL LOG

This is the beginning of your paperwork system. It can take any number of forms, but at a minimum it should tell you the number of the job, the name of the customer, the date the job came in, the due date, and the date of completion. The one shown here does more than that; at the end of the month, the totals at the bottom become the monthly production report.

THE WORK ORDER

The real basis for all your records is the work order—the piece of paper that authorizes you to shoot pictures, to make prints, or to do whatever else is requested. The work order follows the job through the department, telling each person who contributes to the job what to do and when that part of the job is due. Eventually it follows the completed work out to the office, where it tells someone where to deliver the finished prints and where to file the negatives. The work order shown in the illustration is one that I used for several years, and the data it requires and records are those we needed for our particular operation. Such an order may not be suitable for any other photographic unit. You must design one that makes it easy to record the data *you* need in *your* operation, and it is unlikely that any two organizations would have exactly the same

PHOTOGRAPHIC SERVICES REQUISITION

JOB NO. **66B**
DATE IN **2/13/79** @ ____ HRS
DATE DUE **2/21** @ ____ HRS
READY **2/21** @ **1600** HRS

CLASSIFICATION:

- ☐ SRD
- ☐ SECRET
- ☐ CONF
- ☐ NORTHROP PRIVATE
- ☐ NORTHROP SENSITIVE
- ☐ UNCL. GROUP _____

REQUESTED BY **AO-A76 - Glenn Channels** DEPT. _____ ROOM _____ EXT. **1019**

TIME CHARGE **9610 0101 0** | **66B** | **X** | RESPONSIBLE PHOTOGRAPHER **FB/GN**

PHOTOGRAPHIC FILE NUMBERS			INSTRUCTIONS TO THE PHOTOGRAPHER	PRODUCTION RECORD		NO.	BY	DATE	
			WHERE _____	STUDIO & LOCA-TION	B/W STILLS				
			WHEN _____ @ _____		COLOR STILLS				
			WHO _____ (APPROX) NUMBER _____		ROLLS 35/120	B/W	1	GN	2-13
			WHAT _____			COLOR			
				PROCESS CAMERA & LAB	LINE NEG. UNITS				
			① 1 ea PMT of 25 pgs of line art at 50%		LINE POS. UNITS				
					HALF/TONE NEGS.				
					HALF/TONE POS.				
			② B+W shots of DAP in Engineering Lab - Make proofs for Customer selection		COMPOSITE MYLARS				
					PRINTS				
					FME	25	FB	2-19	
4063-5				B/W PRINT LAB	PRODUCTION PRINTS	8	GW	2-21	
19					MURALS				
32					DISPLAY PRINTS				
					PROJECTION NEGS.				
					PROJECTION POS.				
					H.T. POS.				
1017, 24 62391			INSTRUCTIONS TO THE PRINT LAB	COLOR PRINT LAB	PRODUCTION PRINTS				
					DISPLAY PRINTS				
					PROJECTION NEG				
					PROJECTION POS				

ITEM	NO. EACH	SIZE	SURFACE	BW	C	SPECIAL INSTRUCT.	POLAR-OIDS & C.T. COPY NEGS			
PRINTS	2	8½×11	M	Ⓕ	X		35M BW/C			
H/T POS		X					3-1/4×4 BW/C			
PROJ NEG		X					POLAPRINT BW			
		X					COPY NEG COLOR			
							COPY NEG B & W			

INSTRUCTIONS TO THE LINE LAB

	SER-VICES			
	FRAMING PRINTS			
	PROJECTION (HRS)			
	VIEW-GRAPHS			
	OTHER (HRS)			

ITEM	NO. EACH	SIZE	SPECIAL INSTRUCTIONS	RECORDS			
LINE NEG		X		MASTER FILE			
LINE POS		X		LOGGED			
H/T NEG		X					
H/T POS		X		DELIVERY RECORD			
MYLAR COMPOSITE		X		CALLED **2.21** @ **1600** BY **Q**			
FME	1	50%		DELIVERED _____ @ _____ BY _____			
PRINTS		X		REC'D BY **G Channell**			
				DATE **2-21-7**			

The *work order* tells you to go ahead with the job, and tracks its progress to completion.

needs. However, the data recorded here are typical of those needed by a medium-to-large company engaged in at least some military work. The work order should include, at a minimum, the items listed below.

1. Date order received
2. Date completed order is to be delivered
3. Date order is actually completed (may be different from item 2, for any number of reasons)
4. Name of requester, and phone extension
5. Charge account number (who pays?)
6. Military security classification, if any
7. Date, hour, and location of assignment
8. Subject to be photographed
9. Approximate number of shots, and whether b&w or color
10. Your contact at scene of shooting
11. Are proofs required?
12. Number of prints from each negative: size, finish, weight
13. Slides, transparencies, vu-graphs?
14. Special instructions, either for shooting or for lab.

That much is needed before the photographer picks up a camera. After the job is complete, you also need the following data:

15. Number of shots made, and whether b&w or color
16. Number of prints (slides, etc.) actually delivered
17. File numbers assigned
18. Who shot the pictures, made the prints, etc.?
19. Who actually took delivery on the job, and when?

You also need (but will keep on another form) the time spent on the shooting, processing, and printing operations, and who did each of them and when. In some operations, it may be practical or expedient to keep the time records on some portion of the work order. I found it best to keep the time records on a separate time sheet, because they had to be used for several different purposes. Again, all your paperwork must be tailored to your particular requirements; neither my forms, nor those of any other organization, would be likely to meet all your requirements without producing any waste data or missing something important.

Toy racing cars make a dramatic picture in this shot by George Meinzinger for a Mattel, Inc., annual report.

GRAPHICS WEEKLY TIME RECORD

NS 30-387 (R.10-75)

SIGNATURE _Lynn DeLuca_

W/E FRI 4 - 13 - 79

PROJECT	ITEM TASK	CHARGE NO.	JOB NO.	LOT	REQUESTER	SUN	MON	TUE	WED	THU	FRI	SAT
7889	6211		L55	574	Miller		8.0	4.0				
7921	1901		A02	574	Ort			4.0				
7830	1101		L75	574	Trudell				2.0			
9301	0100	620000	K53	x	Peterson				4.0			
9301	0100	320000	L49	x	Shoop				2.0	8.0	8.0	
TOTALS: 40					STRAIGHT TIME		8.0	8.0	8.0	8.0	8.0	
					OVERTIME		—	—	—	—	—	

This *time sheet* is used in one company. Forms are constantly revised as needs change.

THE TIME SHEET

The form illustrated here is one that works where it is being used, and it is the third or fourth version of that particular form. Your department is not a static operation, functioning in a fixed world; as either the company or your unit grows and changes, your paperwork needs will change also. Don't change your forms for the sake of change, but when they fail to deliver needed data, change them to reflect your new requirements. *Some* sort of time record is indispensable; without it you cannot tell what your average negative, slide, or print is actually costing you to produce. Just keeping notes on one or two jobs will not help; your figures will not hold up over the long run, and they will get you into trouble. Keep records on *all* the jobs, and you will be better able to forecast your supply needs, es-

timate costs of future work, and justify your requests for equipment, operating budget, and manpower.

COMPUTING COSTS

Computation of costs requires you to know the total cost of your labor and the total cost of your materials. The labor cost is not just the employee's hourly rate, although that is your starting point.

In most larger companies, management likes to keep track of the total costs involved in each of its operations, and will transfer to the departments you support their share of the cost of your services. Companies do this in a variety of ways. Sometimes it will be done in a way that does not involve you, but don't count on it.

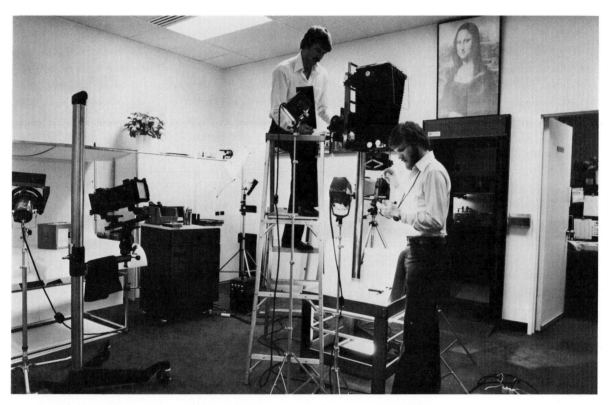

Jack Grossman, a recipient of the Industrial Photographer of the Year Award, was able to persuade his management to let him have the equipment for this superbly furnished studio. Convincing management took top-quality work—and expert record-keeping. Mr. Grossman is good at both. The award is given by the Professional Photographers of America and Eastman Kodak Company. Photo, by courtesy of Lawson Products.

It is probable that the total costs of the man-hours your department spends on work for department XYZ will be charged to XYZ, and deducted from the cost of operating your department. If the work was on a particular project, the charge will be made to that project.

The project or department will be charged for your services at a rate that includes "burden," which is a figure (usually expressed as a percentage) that relates your hourly rate of pay to the total cost to the company of your operation. Typically, such a figure might include the "fringe" costs of insurance and vacations, and other charges for

"occupancy" and "G&A" (general and administrative). This just means that the cost of the building, supplies, advertising, accounting, and various other overhead costs are added to your wages to give a sort of basic cost unit. The time of an employee making, for example, $8 an hour might be charged to the project at $22 an hour, which would be the employee's hourly rate with burden added.

Since "burden" is a percentage, the time charged for an operator making $12 an hour could be $33 an hour. These "burdened" figures are the ones you have to use to figure the cost of your output. Obviously, this makes

your position a bit more difficult when you are comparing internal costs with the prices charged by outside labs.

Under some circumstances, you will be forced to the conclusion that you cannot compete on the basis of price; and if there is no other basis involved, you will send your work outside to be done. Fortunately for the in-house photographer, the price of a print is seldom the prime consideration. Delivery times, protection of proprietary data, and unusual requirements all contribute to the decision whether to do the work in-house or go outside. Thus, the quality of your product—which includes on-time delivery—is a strong factor in the preservation of your job. You still need the figures, and good records; the better you look on both counts, the less often you will be faced with proving that your work is worth more to the company than that of the outside photographer.

CAPITAL ASSETS

Major equipment items which are carried on the books and depreciated by the year are called "capital assets," as opposed to "expense" items, which are charged off completely in the year purchased. The distinction is made purely for tax purposes. The cutoff point that determines whether an item is capital or expense is usually at some arbitrary dollar figure. The last time I wrote a capital-asset budget justification, that figure was $500, which in my company meant that anything I bought that year for less than $500 I could buy over my own signature, and the money for it came out of my operating budget just as the cost of film did. Anything costing more than $500—like a new enlarger—had to be approved as a capital-asset budget item and signed for by several different levels of management.

If you happen to work for a small company, you may be able to buy equipment at any time that its purchase is a demonstrably good idea. In a larger one, the capital-asset budget is assembled and approved once a year, and if your particular request is not approved the first time you submit it, you are out of luck for at least one more year. You will have to put in a formal justification for each piece of equipment you are to trying to buy, and there is usually a specific form to use and a specific format to follow. Always, however, you will be required to justify your purchase request with figures to show that the use of that particular piece of equipment can be expected to save the company money, and how much, and for how long, and how the failure of the company to acquire the equipment will affect your operation. In recent years, unless the chosen piece of equipment could be expected to earn back its cost in two years or less, you could count on rejection of the request.

Sometimes it is easier to show that the on-time delivery of the company's product on a certain contract would be jeopardized by the lack of that particular piece of equipment, and that the rental of it is impractical. For any of these approaches you need figures, and they have to be accurate.

THE FREELANCE BUSINESS

If you are a freelance, running your business at a profit is a matter of survival; and even if you should fall on your face, you'll be expected to explain how and why to the Internal Revenue Service. It is therefore impossible to overstate the importance of keeping records. Save every receipt for every dime you spend that you can connect with the production of income. That includes taxi fare (counting

In making this shot for a client's annual report, Lou Jacobs, Jr., supplemented the ambient light so subtly that it still looks like an existing-light shot.

tips), airline tickets, mileage you drive on a job, batteries you buy for your electronic flash, even the notebook you keep those notes in. You think you'll remember, but you won't, and the Internal Revenue Service will not take your word for it anyway. Write everyting down.

If you have ever had any experience at keeping records for a business, you may want to set up your own books and do your own bookkeeping. But if the thought of setting up depreciation schedules for your equipment *that the I.R.S. will accept* gives you cold chills, you may want to get help.

Business Management Services

Bookkeeping, accounting, and management services are available for the freelance, and you can buy as much or as little help as you need. If all you want is for some expert to add up all your figures once a month and tell you what you have earned and what you have spent (sort of a glorified checkbook-balancer), you can have that for the price of a dozen rolls of Kodachrome. For perhaps twice as much, and we're talking in generalities because at this point we have to, you can hire a service that will keep your records, pay your bills, and file your income tax report at the end of the year. You send the service all your receipts and have all your bills sent there, and the service takes care of everything. If you are even moderately prosperous as a photographer, you cannot afford to spend your professional time and talent on keeping books. You understand the value of professional services in photography, or you would not be in the business; so hire a professional accountant to do your books. It may save you money, and will almost certainly save you a lot of headaches.

A Business Attitude

As a professional freelance photographer, you come in with the edge of being a visiting expert, and you will usually be accorded that status for just as long as you appear to deserve it. That means that as long as you observe the amenities and keep your appointments, people will continue to accord you a somewhat privileged status. But if you walk in unannounced and insist on taking up the time of someone whose schedule for the day does not include you, or if you waste someone else's time by being a half-hour late for an appointment, your professionalism becomes suspect. Some people in business do seem to have time to waste, but most do not, and few people like to have time wasted by somebody else.

Assembly lines, in particular, are sacred in the manufacturing business, and at one time or another you may have to tie one up for a short time to make a specified photograph. Keeping "down time" to the absolute minimum is the only way you will come out of that situation without making permanent enemies. Organize your time around that fact of industry, and you might even be invited back. But if the factory superintendent pounds on the chief executive's desktop about your holding up the line—and superintendents *are* table-pounders—somebody else will probably photograph the annual report next year. Call ahead, make appointments, plan your efforts, and be on time. Or else.

LEGAL RIGHTS AND OBLIGATIONS

PHOTOGRAPHIC LIMITS

As a photographer, you have the legal right to photograph just about anything that you can point your camera at in public, with certain limitations around some government installations, and in some libraries and museums. But there are laws of privacy and trade that limit your use of the pictures after they have been taken. If your photographs are considered an invasion of someone's privacy, or if you use them for commercial purposes without a written release, you may be liable to lawsuit and penalties. Generally, photographs of people shot on private property cannot be used without their permission. Photographs of the same people shot in public can be used as news pictures in magazines or newspapers, but not for advertising. People who are themselves newsworthy, such as enter-tainment personalities, are considered to have given up some of their rights to privacy, and surprise telephoto shots of them are published often.

In most cases, legal restrictions are less likely to inhibit photography in questionable circumstances than are the restrictions of morals, ethics, and good taste. If the question comes up in the course of your efforts as a freelance—and it can—it may be best to shoot the pictures first and ask questions afterward. Let the art directors or editors make those decisions; they get paid for that, and they have probably done it before.

THE MODEL RELEASE

This is a short document that makes it legal for the photographer or the photographer's client to use a photograph in which the "model" appears. A model is anyone whose face is recognizable in the picture. It is customary, when models are not otherwise compensated for their trouble, to provide prints as a manner of courtesy. Having a signed release gives the owner of the photograph the right to use it commercially, as in advertising or in sales brochures.

COPYRIGHT

Copyright is the legal ownership of a photograph (song, book, etc.); all other rights are dependent upon the copyright. If you are a company photographer, your photographs are classified as "work made for hire," and the copyright belongs to your employer.

If you are a freelance, under the copyright law that became effective in 1978 you own the copyright to your photographs unless and

In the hands of Steve Kahn, this photograph of a messy, oily dockside becomes an exercise in design. The photo was taken on freelance assignment for the 1977 annual report of the Buttes Gas and Oil Company. Photo © Steve Kahn

until you sign it away in a specific agreement, subject to certain time limitations. You can learn what those limitations are, and how you can protect your work for the maximum time, by writing to the Register of Copyrights, Library of Congress, Washington, DC 20559. Ask for the Copyright Information Kit and copies of form "VA," which is the form for registering photographs.

As the owner of the copyright, you have the right to restrict the use of your photographs. You can sell to the client the right to use your pictures in an annual report, and later sell him or her the right to further uses of the same pictures for brochures or advertising; or you can sell "all rights" and have no further financial interest in what becomes of your work. It is important to discuss and agree upon rights with a client *before* starting the job.

OWNERSHIP OF NEGATIVES

This is sometimes a point of contention between the freelance and the client, who is often unaware of the established custom that the photographer retains possession of all negatives. As with all other rights that the client is purchasing, it is best to have this point understood from the beginning, and not let it become a problem after the fact. Some clients will absolutely insist on full ownership of the negatives (or slides) and all rights; face the problem at the beginning, and select your alternative. You can give in, and charge enough to make it worth your while; you can sell all rights and keep the negatives, so that you can realize something on the reprints; or you can stand your ground, even if it means losing the assignment. Ordinarily, the matter can be resolved without loss of blood if it is

discussed early and thoroughly. But nobody—least of all the manager of a relatively sophisticated public relations and advertising operation—likes the feeling of having been "had," and some are quite bitter on the subject. One ad manager for a billion-dollar corporation has vowed never again to hire a freelance photographer except under a "work made for hire" arrangement. That's bad for every other photographer with whom he will ever do business, and it could have been avoided if the photographer who provoked the ad manager's ire had been franker in his way of doing business.

Whether you are shooting the annual report, a facilities brochure, or an ad for a national magazine, *let the clients know what they are buying*—and *what they are not* buying but will have to pay for later if it is wanted. Do it *before* you do the job.

One way to do this is to write the client a letter as a "memo of understanding," which spells out the job as you understand it and what rights you are selling as a part of the package. The same listing of rights sold should be indicated on your invoice for the job. In the absence of a written contract, these serve that purpose.

THE LOOK OF PROFESSIONALISM FOR THE FREELANCE

Professionalism is not really a matter of appearances at all, but in many contacts with potential clients and customers your professionalism will be judged on appearances alone. The way you dress, the way you talk, and your attitudes toward the business aspects of your work all contribute to the impressions that lead to the decision to hire or not hire you for a specific assignment.

BUSINESS CARD AND LETTERHEAD

These may be the first things a client sees, and they will tell a lot about your style, your taste, and your attitude toward business. Many of the people with whom you will be doing business are trained and experienced in art and design, and they know good from bad. Bad design is offensive to them, and you don't want them to connect such design with your name.

It is possible to go down to your neighborhood "instant print shop" and for as little as $400 get 5000 each of business cards, letterheads, envelopes, and invoices in two colors; that price includes $20 for "layout." Don't do it. Cheap paper and cheap printing *look* cheap, and they make *you* look cheap. You cannot afford cheap printing, because in the long run it is too expensive.

You need the help of a professional designer, who will lay out your cards, letterheads, and invoices, select the proper typefaces and papers, and see that the actual printing is done by a house that does quality work. Your work may bring you into contact with design people who will be willing to help you, not for free, of course, but for the special prices reserved for fellow professionals. At the very best levels, this kind of design may be available to you for as little as $500 in 1980 dollars. Top quality two-color printing for 5000 each of cards, letterheads, envelopes, and invoices on good stock will cost you $1250 to $1600. That's a large quantity to buy at one time, but it is the nature of such work that cutting the amount by 50 percent will reduce your bill by less than 15 percent; and going back later for another small quantity makes the per-unit cost higher.

Those are the extremes. One is relatively easy on your pocketbook, and tells everyone

The right time of day and the right angle made the difference between a dull record of a concrete structure and this interesting picture. The choice was made by Bill Jack Rodgers of the Los Alamos Scientific Laboratory.

that you probably do cheap work; the other eats up a lot of your profits, but labels you as a quality performer. Falling between these two are a couple of alternatives you might want to consider.

If your own background includes enough training in art and design, you may want to try doing your own layout and artwork. Pick your own paper stock and select your own printer from the regular commercial houses; this can cut your total costs by as much as 50 percent. Try this only if you are certain of your competence as a designer, and if you are really qualified to judge printing quality.

A freelance designer with minimum overhead to support may do your design work for as little as $250. You will still have to pick your own paper stock and select the printer, but you will have the advantage of professional design.

SUMMARY

The in-house photographer is running a business within a business, which should be managed as if the photographer's income depended on showing a profit; often enough, it does.

Good records are those that contain all the data you need, and no more than that. At a minimum you need a central log, a work order, and a time sheet. Accuracy is vital. Controlling your costs requires that you know the total cost of labor and the total cost of materials for each of your products, and these data come from good records.

"Expense" items come out of your operating budget, and you buy them over your own signature as needed. "Capital asset" items are those that cost above a certain figure, are depreciated on an annual basis, and are purchased through the capital-asset budget, which is approved and released annually. Capital items require written justification, based usually on your records.

For the freelance, good records are the difference between survival and failure; even in failure, they will be required for the Internal Revenue Service. There are services available to keep records for you.

The outside-expert syndrome works for the freelance only for so long as it is not abused. Observing the amenities of business is essential.

You have the legal right to photograph almost anything you can see, but the law limits your use of the pictures. Depending on the purpose of the pictures, model releases may be necessary for any prints or slides showing recognizable faces.

Copyright law gives the freelance ownership of all rights to his or her pictures, after which the owner/photographer has the legal right to limit their use to the purposes for which they were bought. It is necessary to have a full prior understanding with the client, and this should apply to the possession of negatives and slides as well as to the rights of ownership in them.

Your business card and letterhead tell clients a lot about you, and it is important that they say the right things; professional design can be a help.

XII

Specialized Photographic Techniques

As noted in the first chapter, industrial photography is not easy to define, and it defies limitation. Related to industrial photography, and impinging on it, are several other fields of photography; some of these are very narrow, and most of them require special training or talents not ordinarily needed for what we usually think of as industrial work. Some photographers find these exotic areas challenging, and job and career opportunities do exist in them.

HOLOGRAPHY

This is a highly specialized kind of photography that uses special optics and laser beams to produce three-dimensional images. The technical limitations of the process have so far kept it from expanding into some fields in which it showed some early promise—advertising displays, for one. However, it does have a place in the jet-engine industry, where it is utilized in nondestructive test work, and small companies are using holography to make everything from 3-D erotica to museum displays.

The optical and physical complexities of the hologram require special equipment and training not available at every school of photography, although such training is available at the Brooks Institute in Santa Barbara, California. The Museum of Holography at 11 Mercer Street, New York, NY, is a clearing house of information on training programs in holography.

SCHLIEREN PHOTOGRAPHY

This is another specialized area in which some extra training is needed. It uses special optics to make shadow pictures of the behavior of gases, and it has its uses in several kinds of research, much of it military. The necessary training is available in some photo schools and at some universities; again, you have to ask questions.

MEDICAL PHOTOGRAPHY

This is a large field. Nearly every medical research center, school, university, and hospital has at least one photographer who is authorized to put the initials R.B.P. (Registered Biological Photographer) after his or her name. Before acquiring this designation, the

Laser experiments related to holography are not available everywhere; this one is being conducted at the Brooks Institute by Gary Russel, Robert Copeland, and Mike Gary. Photo by Mark Evans.

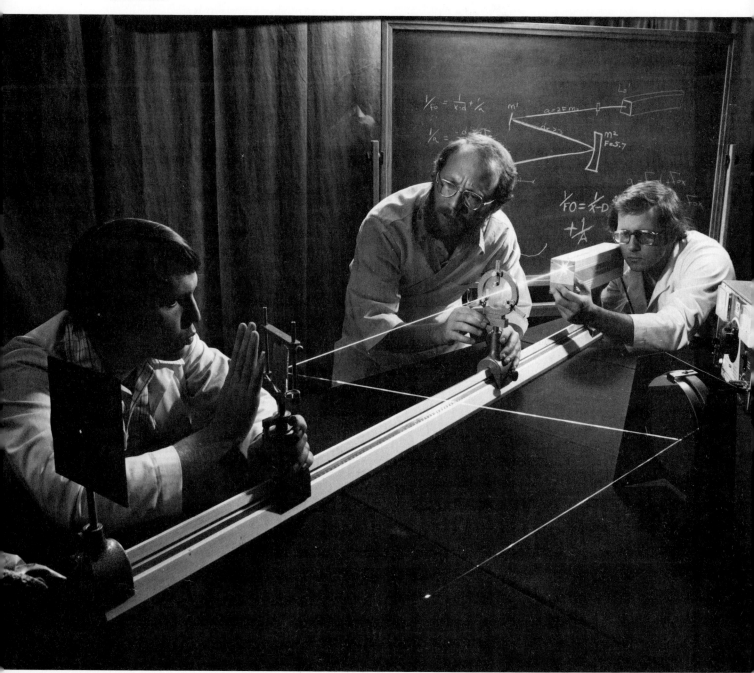

These four frames were selected from a 400-frame-per-second sequence showing steam emerging from 24-inch downcomers in 11 feet of water. Photo by Robert Marshall for Wyle Laboratories.

on the requirements and how to meet them can be had from B.P.A., Inc., P.O. Box 2603, West Durham Station, Durham, NC 27705.

INSTRUMENTATION PHOTOGRAPHY

This is usually motion picture work that normally involves frame rates of 200 to 40,000 per second. In its more exacting operations it also requires an understanding of some fairly sophisticated math and physics, and the training comes pretty close to combining engineering and photography. Again, training is available only at selected schools.

Medical photography is a large field, especially for photographers who can put "R.B.P." after their names. A few schools offer the appropriate training. Photograph by courtesy of the Brooks Institute.

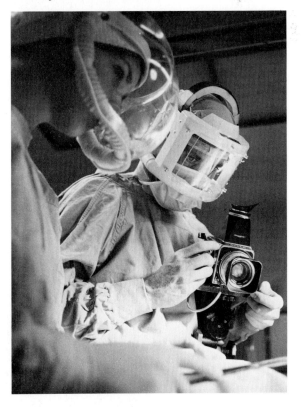

photographer must qualify on both written and practical tests to the requirements of the Biological Photographers Association, satisfactorily complete an internship of between seven and fourteen weeks in an approved medical facility, and have a total of not less than five years' experience in the field. Details

DOCUMENTARY AND SALES MOTION-PICTURE WORK

This field is closely related, in many industrial operations, to photo-instrumentation. Except in the largest organizations, the same people are likely to be doing both kinds of film work, and a lot of instrumentation photography finds its way into the documentary/sales films. Good courses in motion-picture techniques are available at many universities and some photographic schools.

TELEVISION

TV photography is now a part of the motion-picture department in many industrial operations, and video recordings are supplementing or replacing motion pictures in many areas of industry. Closed circuit television (CCTV) is used for surveillance of hazardous test operations, for security, and for training. While motion-picture films of a test coverage must be driven to the lab and processed—normally at least a 16-hour procedure—video tapes can be played back immediately, making video recording a highly useful tool for the researcher and the test engineer. Training in television is available at some schools that teach it exclusively, and at most universities.

X-RAY PHOTOGRAPHY, METALLOGRAPHY, AND ELECTRON-MICROSCOPY

These and other forms of special scientific photography are likely to be performed by

In many industrial operations, the cinematographer must also operate the TV camera. Here Tom Smalley videotapes a training session for a Navy training "film." Photo by Robert Thornton, Northrop Corporation.

**This technician using an electron microscope produces photographs like the one on the left.
Photograph, by courtesy of the federal Center for Disease Control, Atlanta, Georgia.**

people who are primarily skilled technicians in their respective fields and only incidentally involved in photography. Their skills are more likely to be identified with their specific areas of research than with whatever photography is involved in their work. What they need to know about the photographic side of their work they often learn on the job.

MULTIMEDIA PRESENTATIONS

These are a fact of life in many industries, particularly those heavily involved in sales or instruction, and their production presents opportunities for both the company photographer and the freelance. Some in-

153

house multimedia efforts have evolved into separate departments that do nothing else, and even companies that have some capabilities in this area will occasionally hire outside organizations to produce special shows.

Successful production of a multimedia presentation sometimes requires an understanding of the use of tape recorders, dissolve units, programers, slide projectors, motion-picture projectors, and video units, plus the ability to use them all together to produce a coherent show and deliver a specific message to a particular audience. Training in the necessary disciplines is available at most universities and in most schools of photography.

Motion-picture work for industry is different from that for the entertainment world, but it is no less demanding. Tom Smalley, a Northrop cinematographer, is seen here working on a training film. He was photographed by Gil Nunn, also of the Northrop staff.

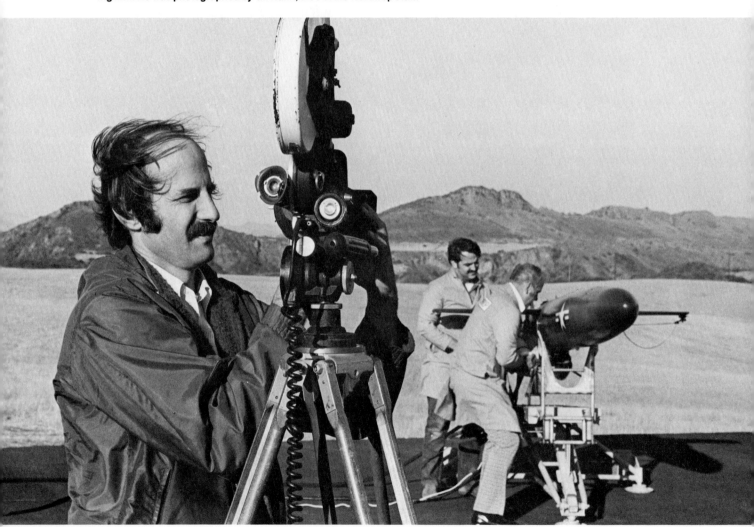

Many companies are now using underwater photography, and this is becoming a recognized specialty. The photographer here is a student at the Brooks Institute in Santa Barbara, CA.

SUMMARY

Broad as our definition of industrial photography is, there are many related fields that touch it. Holography, schlieren, medical, instrumentation, motion-picture, television, scientific, and multimedia work all relate to industrial photography, but each pertains to a specific field and requires special training. Some of them also require additional training in mathematics, physics, optics, chemistry, or medicine; expert training is available for all this work, although not all of it at any one school.

Veteran industrial photographers are willing to share what they have learned with today's students. Here the author confers with a student photographer. The moment was caught by Michael Crummett, a freelance photographer of Santa Barbara, CA.

Afterword

If I have not convinced you by now that industrial photography is a challenging and exciting way to make a living, then I have wasted a lot of my time and yours; but I don't believe that is possible. The pictures in this book alone are proof that while there are some dull ways to make a living, this is not one of them. There are many occupations that will make you more money (some of them are even legal), but in few of them will you find the satisfactions, delights, and surprises that await you in industrial photography.

This is a field that, for women, is ripe for the picking, and I am surprised that so (relatively) few of them are in it. Those who are seem to be doing well, some of them extremely well. I expect that, as the word gets out that this is a good field for women, we'll see more of them profiting from the opportunity it offers. I hope this book will be instrumental in pointing the way; industrial photography will benefit from the special sensitivities and insights talented women can bring to it.

We who have been in the field for the last 25 years or so have seen great changes in the technologies and techniques that support us, and those of you who are in the field a few years from now will have seen much more of the same; the only thing truly certain about the future of industrial photography is that it will be full of surprises. I can only envy those of you who will be contributing to the changes.

Good luck!

Index